Sculpture

sculpture

Jane Hill

TEACH YOURSELF BOOKS

For UK order queries: please contact Bookpoint Ltd, 39 Milton Park, Abingdon, Oxon OX14 4TD. Telephone: (44) 01235 400414, Fax: (44) 01235 400454. Lines are open from 9.00–6.00, Monday to Saturday, with a 24-hour message answering service. Email address: orders@bookpoint.co.uk

For U.S.A. & Canada order queries: please contact NTC/Contemporary Publishing, 4255 West Touhy Avenue, Lincolnwood, Illinois 60646–1975, U.S.A. Telephone: (847) 679 5500, Fax: (847) 679 2494.

Long renowned as the authoritative source for self-guided learning – with more than 30 million copies sold worldwide – the *Teach Yourself* series includes over 200 titles in the fields of languages, business, education, crafts, hobbies and other leisure activities.

A catalogue entry for this title is available from The British Library.

Library of Congress Catalog Card Number: On file

First published in UK 1998 by Hodder Headline Plc, 338 Euston Road, London, NW1 3BH.

First published in US 1998 by NTC/Contemporary Publishing, 4255 West Touhy Avenue, Lincolnwood (Chicago), Illinois 60646–1975 U.S.A.

The 'Teach Yourself' name and logo are registered trade marks of Hodder & Stoughton Ltd.

Cover photo from a woodcarving by the author.

Typeset by Transet Limited, Coventry, England.
Printed in Great Britain for Hodder & Stoughton Educational, a division of Hodder Headline Plc, 338 Euston Road, London NW1 3BH by Cox & Wyman Ltd, Reading, Berkshire.

Impression number 10 9 8 7 6 5 4 3 2 1
Year 2002 2001 2000 1999 1998

CONTENTS

ACKNOWLEDGEMENTS

The author and publishers would like to thank the following galleries and individuals for permission to reproduce photographs of their work: Lindsay Anderson, Alexandra Harley, The Henry Moore Foundation, Lin Jammet on behalf of the Frink Estate, the Lipchitz Estate, Roger McFarlane, The Trustees of the Tate Gallery, The Trustees of The Victoria and Albert Museum and Nina Williams on behalf of the estate of Naum Gabo.

The author would also like to thank Mac Campeanu, Head of Digital Arts at the City Lit, London, for help with imaging on pages 9, 10, 19, 104, 116, 118 and 120.

Dedication

For Martin and Anna

All drawings © Jane Hill

INTRODUCTION

This handbook introduces the new sculptor to a range of materials and techniques, starting with simple exercises and proceeding to more challenging projects. It assumes that the reader has little or no knowledge of sculpture. Each section aims to cover some of the many topics associated with the subject, from its historical origins to explanations of the main techniques used in making sculpture.

A definition

Sculpture is an art form that traditionally stands in space. It may have been modelled, carved or constructed.

Modelling

This is a process whereby form is built up out of malleable material such as clay or wax. Modelling is not just a way of manipulating to form shapes for sculpture but also a way of working out ideas: a kind of three-dimensional thought process.

Carving

This involves cutting away or subtracting material; this technique is generally associated with stone, wood or bone, but many other materials can be carved: leather-hard clay, plaster, polystyrene or building blocks. Carving requires some care, as material that has been removed cannot be replaced.

Construction

This means building sculpture out of ready-made or pre-formed parts. Constructions can be made from individual materials such as wood, metal, plastics and 'found objects', or combinations of these. There are no specific techniques associated with constructing other than a range of jointing and fastening methods, such as welding, riveting or gluing.

Casting

Apart from the three basic methods of making sculpture, there is another important process that most sculptors should learn, and that is casting. Casting is taking moulds from sculpture made of fragile material like unfired clay, and filling these moulds with more durable substances such as plaster, concrete or bronze. Without casting, most modelled sculptures would have perished.

Some sculpture makes mess but, with some basic preparation and tidy work methods, most of the projects covered in this handbook can be done in a limited space at home. Only carving needs a special area with a rigid floor. If access to such an area is difficult, I would recommend joining one of the many adult education centres offering carving courses. Joining such classes would give some first-hand understanding of techniques and the use of tools before you decide what to do.

1 | SOME ORIGINS OF WESTERN SCULPTURE

Sculpture has been made almost everywhere in the world since prehistoric times. It seems that there is an inherent tendency in man to create three-dimensional objects, with all manner of materials and for a wide variety of reasons. We tend to assume nowadays that sculpture is made solely for the purpose of making beautiful works of art; but in many cases, sculpture has been made for religious or political purposes, or to articulate a piece of architecture. Evidence of a concern for pleasing shape, symmetry and polished surfaces is apparent even in these small carvings that were made over 20,000 years ago. The exaggerated femaleness of the forms in these 'Venus' figures suggests that they were probably fertility figures.

**Figure 1.1(a)
From 'Venus de
l'Espugue'
(Musee de
l'Homme, Paris)**

**Figure 1.1(b)
From 'Venus of
Willendorf'
(Natural History
Museum, Vienna)**

**Figure 1.1(c)
From a Cycladic
figure at the
British Museum**

The function of later Cycladic figures of 2,700 – 2,300 years ago is less obvious; most of the sculptures found have been of female figures standing with folded arms, but again, their simplicity and symmetry is remarkable.

Egyptian sculpture

Sculpture became an essential part of life and death in ancient Egypt, but very few sculptures were made for artistic reasons alone. Their purpose was practical: to provide representations of kings and other dignitaries in cult offerings and mortuary services within the tombs and temples. There were many centres throughout Egypt producing mortuary sculptures that followed strong conventions in style, proportions and form. Such strict

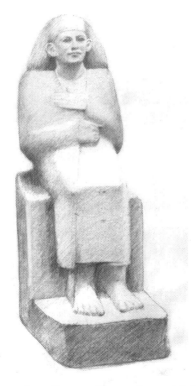

Figure 1.2 Egyptian figure from the British Museum

adherence to tradition meant that there was little variation between sculptures produced in the many centres, particularly in the Middle and New Kingdoms of 2050–1560 BC. The finest Egyptian sculpture was made for the great temples where statues would serve as substitutes for kings in rituals to the gods.

Portraits of kings and their wives were done to a formula, either seated or kneeling and looking straight ahead, or standing in a set pose, the men striding and the women standing straight. Although death masks were taken from subjects prior to sculpting, portraits took on an ideal rather than observed form, and style remained roughly the same for three thousand years.

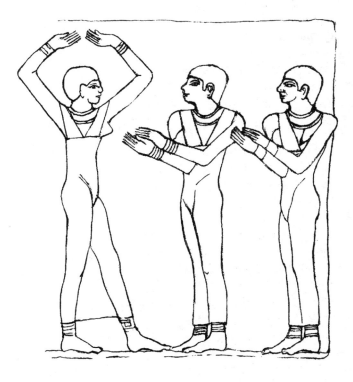

Figure 1.3 Part of a relief from the British Museum

There was far more expression and animation in the relief sculptures and painting than with the formal portraits and other sculpture. The small section of a relief decoration in the British Museum shows a girl dancing to the singing and clapping of two other girls. Such scenes are typical of the type found in the walls of tombs depicting scenes from the life of the king.

Greek sculpture

Marble sculptures that were made in Greece during the seventh century BC were based on Egyptian types, but during the sixth century the somewhat stiff formula was refined. Whereas Egyptian sculptors worked with what they knew to be right, Greek sculptors used their eyes to learn about the human form. Early experiments in bronze-cast sculptures date from this time.

The fifth century BC is generally seen as the classical era in Greek sculpture: it was a time when sculpture began to show a real understanding of movement and expression. The athletic nude male or the carefully draped female gave carvers excellent opportunities to show their skills and virtuosity in sculpting the human figure, though facial expression remained largely impassive until the fourth and third century BC.

Towards the end of the Hellenistic period compositions, poses, drapery and facial expression were all greatly exaggerated to create more theatrical and dramatic effects in a change from the elegance and poise of the classical period.

Figure 1.4

The impact of Greek sculpture spread eastwards towards Iran and India with the conquests of Alexander the Great. Artefacts imported or copied from Greek originals have been found as far east as Afghanistan.

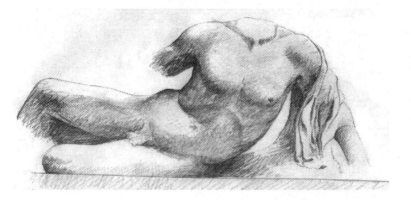

Figure 1.5 From a heroic figure of the Parthenon at the British Museum

Roman sculpture

Many Greek sculptors were employed in Rome, and under various Roman emperors the Greek style flourished. Most Greek sculptures are known to us now through Roman copies.

Portraiture thrived under the Romans. Lifelike facial realism distinguishes Roman sculpture from Greek sculpture, and it is probable that sculptors used death masks to achieve a likeness. These portraits in the British Museum show remarkable individuality: there is no attempt to idealise or flatter the subject (see Fig. 1.6).

Architectural motifs were used to create an illusion of space and depth in Roman friezes, such as the one shown, from a section of Trajan's Column (Fig. 1.7). There is no understanding of perspective as we know it; this method of describing space was not fully explored until the fifteenth century in Italy. (Compare this with Plate 9.)

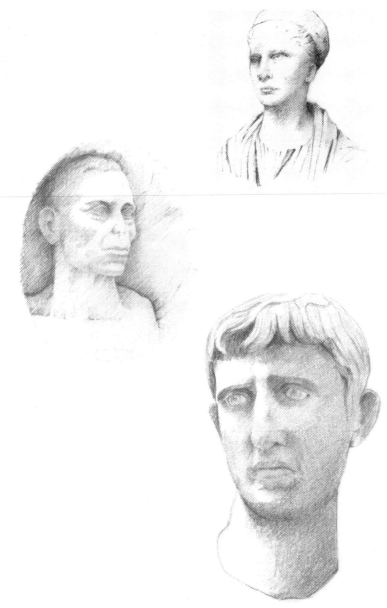

Figure 1.6 Roman heads in the British Museum

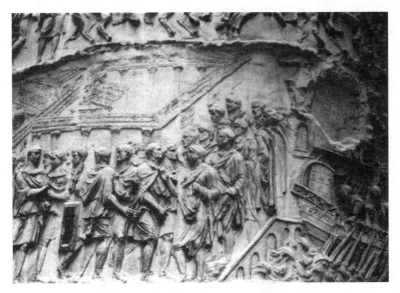

Figure 1.7 Section of Trajan's Column

Gothic sculpture

Romanesque and Gothic churches were decorated with sculptures that
were not necessarily religious in theme; columns were embellished with

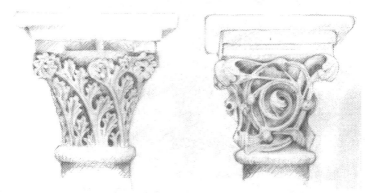

Figure 1.8 Capitals from Lâon Cathedral, France

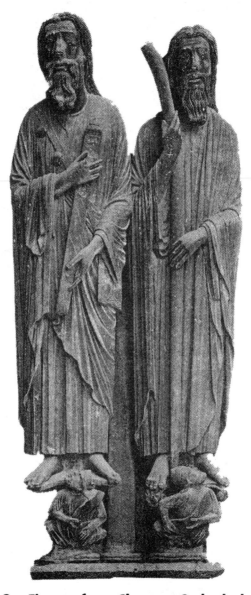

Figure 1.9 Figures from Chartres Cathedral, France

plants or beasts as well as scenes from everyday life. These fine twelfth-century capitals from the cathedral at Lâon in France show exquisite detail of plant forms (Fig. 1.8).

Gothic sculpture was generally used to articulate architecture, and sculptors were considerably subordinate to the master masons and architects who constructed the cathedrals and churches. The word 'Gothic' is slightly misleading in that the style was not invented by the Goths or Germans but originated in twelfth-century France. Early Gothic figures tended to be elongated in form, with clinging drapery in seemingly wet folds, such as the two from the cathedral in Chartres (Fig. 1.9). A century later, everything about the figure is less exaggerated, the attitude more natural, and the drapery simpler, as seen in the thirteenth-century statue from the cathedral at Amiens (Fig. 1.10).

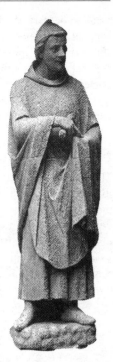

Figure 1.10 Figure from Amiens Cathedral, France

Renaissance sculpture

The Renaissance style originated in Florence in the fifteenth century. The word 'Renaissance' refers to the 'rebirth' or return to the antique style of Greece and Rome. It was curious that the movement should start in Florence, as there were few classical buildings or statues in that city; Florentine architects and sculptors travelled to Rome to draw inspiration for their work, and it became fashionable to collect antique sculpture. Such a collection of Lorenzo de' Medici, the great Florentine patron of the arts, was of great benefit to the young Michelangelo.

Michelangelo made the first large-scale nude figures since antiquity, and the 'Captive Slave' of 1514 is one of many sculptures he created celebrating his ideal vision of male beauty. The sculpture shown in Fig. 1.11 was probably

made to be part of a tomb for Pope Julius, but was not completed. The fetters round the neck and wrist look more symbolic than effective, and just give a hint of narrative to an otherwise sensuous study of the male nude. The design fits economically into the block of marble which still retains an area of uncut stone.

Baroque sculpture

The seventeenth-century Baroque style is likely to have been derived from the word 'barocco', meaning 'strange'. Baroque sculpture is typically full of movement and theatrical in effect. Most of the best sculpture of the period was made in Rome, and the most inventive sculptor was Bernini.

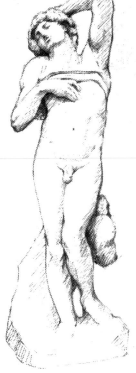

Figure 1.11 From a cast of Michelangelo's 'Slave' at the Victoria and Albert Museum

Bernini used an amazing range of devices to enliven his designs: false perspective, dramatic lighting, fluttering drapery and energetic poses animate his compositions. The 'Neptune and Triton' in the Victoria and Albert Museum (Plate 1) is an early example of his Baroque sculpture. It shows the god Neptune either summoning or quelling the deluge by stabbing aggressively at the seas with his trident. His fierce facial expression adds drama to the composition and the swirling drapery exaggerates the twists of the body.

Neo-classical sculpture

Baroque, and later Rococo art spread throughout Europe in what Gombridge calls 'an orgy of decoration', and it is natural to assume that there would be a return towards a simpler style with neo-classicism in the eighteenth and early nineteenth centuries. The Italian sculptor Canova looked back to ancient Greece and Rome for themes as well as style in the 'Theseus and the Minotaur' of 1782 in the Victoria and Albert Museum. Classical themes and mythology were common subject matters in a great deal of eighteenth century sculpture.

By the middle of the nineteenth century, sculptors from all over the world were working in Rome, not just to study the abundant antique sculpture in the city, but to employ the local craftsmen to help produce their work. In some cases, up to 50 copies were made of any design by teams of skilled Italian marble carvers.

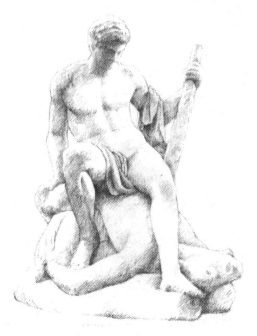

Figure 1.12 From 'Theseus and the Minotaur' by Canova, at the Victoria and Albert Museum

Late nineteenth-century sculpture

Rodin was one of the first sculptors to rebel against the restraints of neo-classicism and, like Michelangelo, conveyed his feelings and responses to

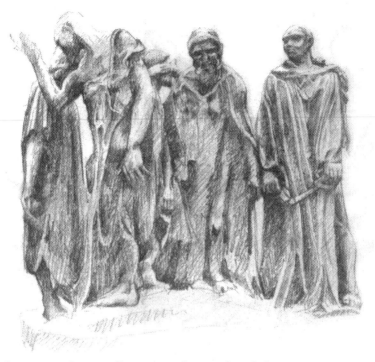

Figure 1.13 Rodin's 'Burghers of Calais', 1884 (Millbank Gardens, London)

the human figure in the most expressive sculptures. Light fascinated Rodin, as it had fascinated his contemporaries, the Impressionist painters. He was known to cast candlelight over his sculptures to see how light reflected and moved over the surfaces to enhance the forms.

Exaggerated facial expressions and gestures are particularly evident in Rodin's 'Burghers of Calais' of 1884. The sculpture records the scene where six sackclothed burghers offered themselves as hostages to the English in exchange for raising the siege of Calais in 1347. The project

gave Rodin the opportunity to experiment with drapery which was as melodramatic in telling the story as the facial expressions.

The attitude of the head and gesture of the hand in the detail of one of the burghers epitomises the despair Rodin wished to portray in this moving sculpture.

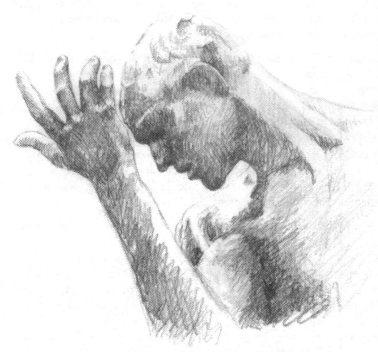

Figure 1.14 Detail of Rodin's 'Burghers of Calais', 1884, showing Pierre de Wiesant (Millbank Gardens, London)

Sculpture in the twentieth century

Early twentieth-century artists used exotic sculptures for inspiration. African tribal art, primitive prehistoric, pre-Columbian and Far Eastern art were all absorbed into sculptors' visual vocabulary. Matisse and Picasso and others experimented by accentuating and abstracting form in response to influences from these different cultures.

Cubism in sculpture was interpreted by artists such as Archipenko, Laurens and Lipchitz, who often used the same motifs as the Cubist painters: still life, harlequins and musical instruments. They also simplified forms into planes and geometric volumes. The 'Still Life with Musical Instruments' of 1924 by Jacques Lipchitz (Plate 2), in the Tate Gallery, is a good example of this simplification of form. The sharp angles and planes create a wide variety of tones to the composition, which was originally made in clay and cast in plaster of Paris.

Cubist painters frequently fragmented their subject-matter and assembled these fragments (which were sometimes painted from different viewpoints) into one image. This concept was attempted three-dimensionally by the Italian Futurist sculptor Boccioni with his 'Unique Forms of Continuity in Space' of 1913 (Plate 3). Successive viewpoints of muscle movement have been assembled into one dynamic and vigorous composition. Many preliminary photographs were taken for this sculpture so that the concept of speed and movement was captured. Boccioni belonged to a group of artists known as Futurists, whose aims were to celebrate the speed of the machine age.

Russian artists were also influenced by Cubism, and their use of abstract form, combined with their replacement of traditional sculptural materials with wood, metal, card and celluloid, had a profound influence on twentieth-century sculpture. Mass and volume was suggested, rather than stated, by enclosing space within clean lines and planes as in the 'Head' of 1916 by Naum Gabo (Plate 4) in the Tate Gallery. Later sculptures by Gabo and other Russian artists such as Rodchenko were not figurative constructions but abstract compositions made of geometric forms and lines interrelating with space.

Modern sculpture in Britain owes a great deal to the Frenchman Henri Gaudier-Brzeska and to the American Jacob Epstein, who both joined the short-lived 'Vorticist' movement before the First World War. This movement embraced some Cubist ideas, and the 1912 portrait of Horace Brodski by Gaudier-Brzeska is a good example in sculpture (Plate 5).

After the First World War there was a revival in the art of carving, with sculptors such as Barlach working in Germany and Moore, Hepworth, Dobson, Gill and Epstein in England. The most exciting aspect of this period was the innovative method of 'direct carving' where the sculptor would work straight into the stone after preliminary drawings, rather than

scaling up a small model or maquette. Massive, simplified figures anticipated future abstract styles where form was appreciated for its own sake, rather than as a means of interpretation.

Modern methods of construction in the building industry have given sculptors opportunities to broaden their methods of fabricating sculpture. Construction steel has been used by sculptors such as Richard Serra and Donald Judd in the US and by Anthony Caro in the UK. Skilled construction workers have been employed to assist artists like David Mach and Anthony Gormley in making their most ambitious and monumental projects.

Sculpture has now become too diverse, in both method of manufacture and in design concept, to label any particular group of artists with a name or style. The subject has also expanded to include such disciplines as installation, performance art and video. Sculpture has drawn on the imagination and creativity of countless talented individuals over generations, and long may it continue to do so.

2 | MODELLING IN CLAY AND OTHER MATERIALS

It is as well to visit the local art shop to see the different modelling materials that are available. Otherwise the 'Useful addresses' section at the end of the book lists plenty of suppliers who will dispatch clay and other materials.

Clay

Clay has been used as a modelling material since prehistoric times. It can be squeezed, pinched, coiled and moulded with hands, knives or modelling tools into a limitless variety of shapes.

Most art shops will sell clay, either modelling clay or terracotta. If you buy from a pottery suppliers, make sure the clay is suitable for modelling rather than pottery, since the range on offer may be bewildering. Porcelain, for instance, is not suitable for direct modelling in sculpture. Modelling clay has the best texture and plasticity for the sculptor; it is also cheaper than other modelling materials and can be recycled. However, clay has its disadvantages: it is fragile when dry and unlikely to survive unless fired or cast, and it cannot be left to dry on armature wire; it will crack or break as it shrinks when drying.

Nylon-reinforced clay

To overcome the need for firing or casting, other types of clay are available that are self-hardening: these clays are reinforced with nylon. Chemical hardeners can be mixed in some makes for extra toughness, and heating in a domestic oven can also add to general durability. There are a number of makes: Newclay, Das and others, all of which are sold ready to use. The disadvantages of nylon-reinforced clays are that they have less plasticity and cannot be recycled, and so great care should be taken with an opened bag to avoid the clay drying or hardening.

It is important to keep clay moist, and both types can be kept in good working condition by occasional damping with a water spray. If unfinished clay work is left for even a short period of time, it should be covered with a plastic bag to prevent hardening. If clay does harden to an unworkable state, cover with some lightweight cloth and spray lightly with water. The clay will re-absorb the moisture from the cloth, but it must be done slowly, since saturation will cause the clay to oversoften and break.

Plasticine

Another good modelling material is plasticine. It is particularly good for small models and works easily when softened in warm hands or near a radiator. It will not shrink or distort (unless dropped) and is ideal for making maquettes.

Figure 2.1 Physalis used as a starting point for clay shapes

Getting started with clay

You will need:

- a small bag of clay
- a modelling board or piece of scrap wood about 12″ square
- modelling tools or an old knife or spoon
- a nylon clay-cutter or piece of fine wire (to cut the clay)

It is a good idea to experiment with the clay at first. Try rolling and twisting small amounts of clay into knots or spirals, or scooping out shapes from a block. Build up units of geometric or organic shapes: don't plan anything, just see what happens when you move the clay around.

Avoid making the clay too thin: it will flop or tear and its limitations will soon be realised. Experiment with solid shapes based on 'found' objects or stones; exotic fruit and vegetables can also provide inspiration for shapes (Fig. 2.1). Keep making new shapes without discarding the old: it is amazing to watch the variety of ideas that develop. Sometimes a simple shape will suggest a subject; for instance, two rolls of clay joined in a certain way might suggest a resting cat. A little pulling and pinching will produce ears and a nose, and the addition of a tail and two feet makes a recognisable cat if not a serious work of art. Some observational drawings or photographs can help with proportions if you are encouraged to do a more detailed model.

The bronze cat in the British Museum represents the goddess Bastet, revered by ancient Egyptians. Cats were domesticated by the Egyptians, and there are many fine sculptures like this one.

Figure 2.2 Model of Bastet in the British Museum

Twisted coils of clay can produce good abstract forms of their own, but they might also suggest other forms such as a reclining torso. Stacking cubes in a haphazard arrangement could suggest a hunched figure – but the main thing is not to have a preconceived idea to begin with. Just enjoy the clay (Fig. 2.3).

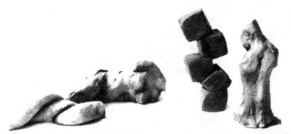

Figure 2.3 Letting clay suggest ideas for sculpture

The ruminating cow shape just 'happened' while pushing the clay around, but a little research helped to bring the model to a better conclusion, particularly where knowledge of cattle is limited. When doing visual research for sculpture, it is important to obtain as much information as you can from all sides of the subject where possible.

Figure 2.4 Cow:

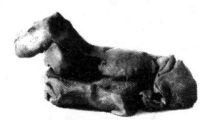

First idea

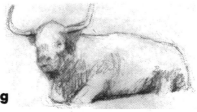

Research drawing

Working towards a final clay model

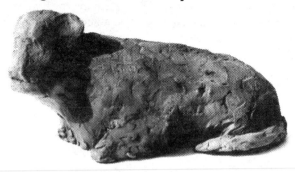

Figure sculptures can be made in clay without an armature or frame, provided they are posed so that they need no support. This small study for a River God in the Victoria and Albert Museum by Giambologna (or Giovanni da Bologna) is in a semi-reclining position that is ideal for clay with no armature. The freshness of texture and freedom of modelling show how much the sculptor has enjoyed concentrating on major movement and musculature.

Figure 2.5 Giovanni da Bologna, 'Study for a River God' (Victoria and Albert Museum)

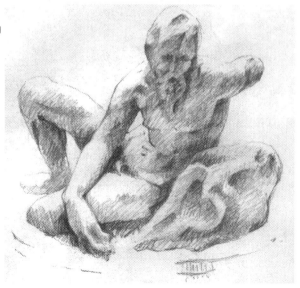

**Figure 2.6
Giovanni da
Bologna, 'Study for
a River God'
(Victoria and Albert
Museum)**

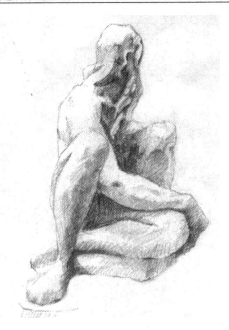

The pose would have been established quickly with rolls of clay at the right angles. It is important that the base is adequate enough to support the figure. It not only keeps the limbs in place but provides a reservoir of spare material should the body or legs need to be lengthened.

Once the pose is established, clay can be added to build up the profiles and muscles. Heads tend to be a problem while the clay is wet; they can be supported with a peastick or piece of metal coathanger wire passed through to the body. The support stays in place until the clay has stiffened sufficiently for the head not to flop, and can then be carefully removed.

The 'Seated Youth with Pan Pipes' attributed to John Flaxman in the Victoria and Albert Museum is another example of a clay sculpture that has been designed without an armature. The pose is compact, well balanced and without the need for structural support. Provided the clay is not expected to stand too high or thin, many sculptures can be made this way.

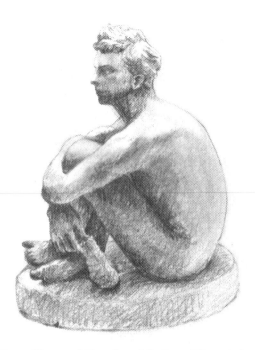

Figure 2.7 'Seated Youth with Pan Pipes', in terracotta clay, attributed to John Flaxman, in the Victoria and Albert Museum

Drying a finished piece of clay

Clay must be dried carefully if it is to survive whole. Thin parts should be wrapped in plastic to ensure that the denser areas dry evenly. The whole sculpture can be loosely wrapped in plastic and exposed carefully over 2 or 3 days to ensure slow drying.

If the sculpture is to be fired, thick parts will have to be hollowed. The rest must be pierced with wire from underneath to release any trapped air, or else the sculpture could burst. Firing thick clay pieces has to be done slowly. Local colleges or potteries may provide a firing service at a small charge if you do not have access to a kiln.

Figure 2.8 Hollowing out a clay figure for firing

Figure sculptures such as the small clay pieces by Giambologna and
Flaxman were done, if not directly from the life model, then from detailed
knowledge of the human body. It is impractical to suggest that everyone
knows human anatomy, but the reason for this discussion is to point out
what kinds of shapes can be made from clay without support from an
armature.

Project: Modelling a standing figure in nylon-reinforced clay

Standing figures need support from an armature if they are to be made out
of clay. Armatures give the sculptor greater scope for designing upright or
standing figures. Unfortunately for sculptors, humans and animals carry
the greater part of their bodyweight at the top, leaving a considerably
smaller volume at the base to support the mass.

The armature itself will need to be held by a support. This could be made
out of plumbers' piping (Fig. 2.9a), but it might be worth investing in a
sliding armature support from a sculptors' shop (Fig. 2.9b): they give great
flexibility for a variety of designs. Choose a 15″ (381mm) armature
support for work up to one-third life size, and a larger support for really
ambitious work. If necessary, a shelf bracket can be used until a more
suitable armature support is purchased or made.

**Figure 2.9(a)
Armature support
made from plumbing
pipe and the Scopas
adjustable armature
support.
© Tiranti Ltd, London**

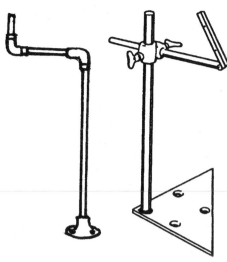

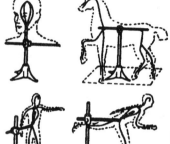

**Figure 2.9(b) Examples of
uses of the sliding armature.
© Tiranti Ltd, London**

You will need:

- armature wire or coathanger wire
- a method of support for the armature
- tie wire
- a pair of pliers
- a drill
- a modelling board or thick piece of wood supported by two batons

The best type of armature wire is aluminium; it is easy to bend and comes in a variety of sizes, from ⅛" (3.17mm) to ⅜" (9.53 mm) widths, but unless there is a local supplier, coathanger wire will do. Coathanger wire is good as it is stronger and less likely to sag than ordinary wire. It will have to be bound with thinner tie wire in order to stop the clay sliding, and the whole armature can be fixed to the support and modelling board as illustrated in Fig. 2.9c.

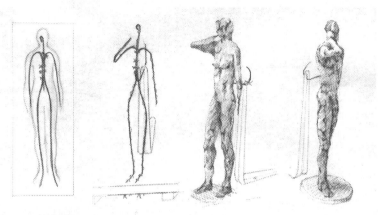

Figure 2.9(c) Modelling a standing figure

It is essential to make the proportions of the armature right. A scale drawing to work out lengths would be a good plan; the wire can be laid over the drawing and adjusted. Allow a little extra for the legs, as the wire has to pass through the clay base.

When the armature is ready and the pose is set, clay can be pressed onto the wire in small lumps and left to stiffen slightly; it will provide a more stable basis for the modelling. The larger masses round the trunk can be padded out with strips of polystyrene (old ceiling tiles are good for this). These can be fastened with tie wire and covered with clay.

Clay can now be added to the larger areas. Use fingers, modelling tools or a piece of smooth wood to pat the clay into shape. Turn the work frequently to build the form on all sides. As the sculpture develops, smaller pieces of clay are added to create the final surface and texture. If the sculpture is small, avoid too much detail; it will emphasise one area at the cost of the rest of the piece. The same goes for deep shadows. Stand

Figure 2.10 Figure in nylon-reinforced clay

Figure 2.11 Giving extra support to a standing figure. From a cast of Michelangelo's 'David' at the Victoria and Albert Museum

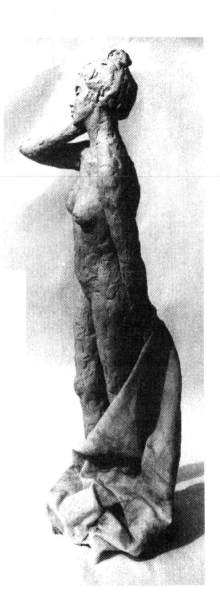

back and look at the work through half-closed eyes to see that the textures, tones and details are consistent throughout.

An extra support can be designed to help add stability. It is quite an old trick: Michelangelo's 'David' sculpture has some discreet branches propping the back leg, which are not noticeable until you look for them. Sculptors have used a variety of objects to support their sculptures: devoted dogs or bits of tree are popular with male figures; falling drapery for women. It all helps to give extra volume to the base of the sculpture (Figs 2.10 and 2.11).

Remember that the clay should be kept sprayed and covered between working sessions (except for the first layer, which can stiffen slightly). A light spray of water will do since the clay will 'sweat' if covered well.

When the clay sculpture is finished, it should be dried fairly slowly: thin areas should be covered to begin with to avoid rapid shrinking and cracking. The dry sculpture should be painted with a hardener and removed from the modelling board by untwisting the tie wires beneath it. These can be trimmed with pliers afterwards.

If the nylon-reinforced clay has cracked after drying, it can be filled with epoxy paste: wet clay will not adhere to the dried material. The sculpture can be finished with a bronze paint if wished.

Modelling a head in clay

As a more ambitious project involving more advanced techniques, a head can be modelled in terracotta, modelling clay or nylon-reinforced clay. Slight variations in the supports or armature will be needed for the different types of clay, depending on whether the clay is to be cast, fired or dried (as in the case of nylon-reinforced clay).

The first method will be for a cast head. Variations will be described at the end of the chapter for preparing the bust peg for a fired clay head and a nylon-reinforced clay head.

Preparing clay for a cast head

A head sculpture, whether it is a portrait or an abstract composition, needs to be supported while modelling, particularly when working in clay. Supports can be ready-made armatures called bust pegs; alternatively, similar armatures can be made out of a variety of materials without too much effort.

You will need:

- a bust peg (head armature) and a modelling board
- 10kg of either modelling or terracotta clay
- aluminium or strong wire: two lengths of 40cm × ¼ inch (6.35mm)
- a jubilee clip or 8 netting staples to hold the wire
- modelling tools
- calipers (bought or homemade)
- a clothespeg
- some tie wire
- a hammer
- a screwdriver

All can be purchased from a sculptors' shop or made with materials bought from a local hardware shop.

If a bolted bust peg is not available, a homemade support can be made out of a piece of square wood fixed to a modelling board with angle brackets. The suggested size is 40mm square by 200mm long. It can be made with two batons of wood under the modelling board to allow room for protruding screws, as illustrated (Fig. 2.12).

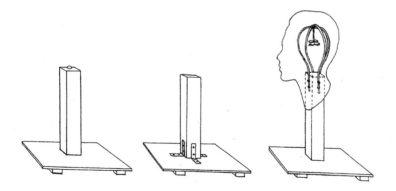

Figure 2.12 Bolted bust peg
Homemade bust peg
Bust peg with armature wire and butterfly

Fix the armature wire in two loops with either netting staples or a jubilee clip. Cross the clothespeg and tie with wire to the armature loops: this is known as a butterfly and it will help to keep the clay in place. This makes a framework on which to model the clay, and will allow the freedom to design the sculpture without worrying about stability: heads tend to be unbalanced, with most of the weight at the front (Fig. 2.13).

If there is a model, let him/her sit in a natural position with a slight turn of the head. Someone sitting bolt upright will produce a most unnatural sculpture! Look at the angle of the neck and press the clay onto the bust peg, starting with the pit of the throat. Build the clay up at an angle to the top of the throat, then start to build out the chin to the correct length. This would be a good time to take the first measurement with the calipers. Always start with the profile.

Once the chin is established, the clay can be tightly packed onto the butterfly and the rest of the armature. A baton of wood will compress the clay and shape it roughly. Measure and mark the top of the head, the line of the eyes, the nose and the mouth. Mark in the planes of the face.

Check the width of the head, using the same mark lines as before. Build up the 'hard' areas of the head: the bone structure of the chin, cheekbones and forehead. It can be quite useful to refer to an illustration of a skull at this stage to help become familiar with the bone structure.

When the basic shape is established, concentrate on modelling all the profiles. Turn the model frequently and note how the profile changes with every view.

The nose: this is best modelled in profile first. Measure it carefully, as it is often overstated in size by novice sculptors: the bridge of the nose is usually halfway up the head and only half the nose protrudes from the face, whilst the other half recedes into it.

The mouth: it is essential to observe how three-dimensional the mouth is (think of a set of false teeth); a great deal of the mouth can be seen in profile.

 1 Draw the shape of the mouth from measurements taken with calipers.

 2 Place two rolls of clay to mark the lips. Add another to mark the chin and upper lip.

 3 Model the shape of the lips with a fine modelling tool to accentuate the edges.

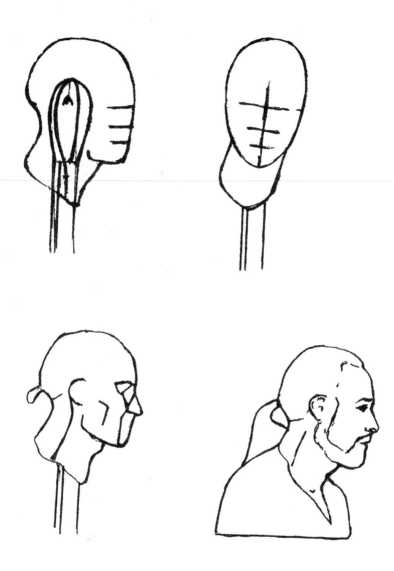

Figure 2.13 Measure the top of the head, the line of the eyes, the nose and the mouth

4 Make sure that the profile of the mouth is evident from the side. Note how far back into the face all the features are situated: they are not on a flat plane like a mask (Fig. 2.14).

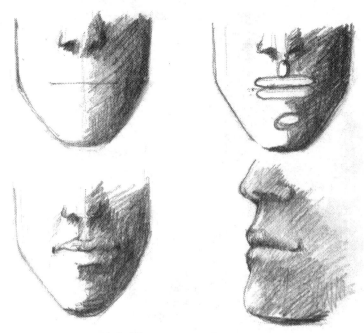

Figure 2.14 Modelling a mouth

The eyes: there is no set way of approaching the eyes; indeed Rodin seemed to have used a different technique for each individual head he sculpted, depending on the age, sex and expression of the model.

The essential thing to remember is that eyes, like mouths, are not flat; they can be seen clearly in profile. The visible part is just a section of a complete sphere fitting into the eye socket, and should be treated as such. Here is one method:

1 Put a ball of clay into a deeply set eye socket.
2 Place two strips of clay, roughly the shape of the eyelid, over the eyeball. Mark the edge of the skull with clay
3 Use a modelling tool to shape the eyelids: the thickness of the eyelids will need to be exaggerated to create a sharp

shadow in place of that made normally by eyelashes. Mark in the iris by depressing the clay with a modelling tool to the correct shape. Note how the top and bottom of the iris are obscured by the lids: modelling a complete circle will give the head an alarmed expression.

4 Finish by adding the pupil quite near to the top eyelid.

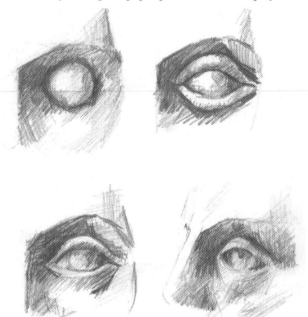

Figure 2.15 Modelling an eye

Another method of approaching eyes:

Make an eye socket, but not too deep. Apply two heavy rolls of clay roughly the shape of the eyelids, and refine with a modelling tool. Add two small pieces of clay to each corner of the eye to indicate the 'whites' of the eye. Shape the iris with a small modelling tool by pushing gently against the 'whites'. The eye will be deeply set and dark in tone: something which is quite suitable for an older-looking head.

Hair can be used to great effect as a contrast to the modelling of the face. Follow the natural fall of the hair with strips of pulled clay to encourage lively shadows, particularly around the face. It is not a good idea to

scratch impressions of hair with tooth-edged tools, as clay cannot be disguised as hair. It is better to allow the material to be truthful to itself.

Finishing the sculpture. Decide whether the shoulders are to be part of the design, or fix the neck to a base with a mounting bolt. This is a matter of taste and suitability.

Preparing a head sculpture for firing

If a head sculpture is to be fired, the bust peg must be prepared in a different way than for a sculpture that is to be cast.

You will not need armature wire; indeed it would be a hindrance.

Cover the wooden post with newspaper and secure with tape. This will allow the clay sculpture to slide off the wooden post when completed (Fig. 2.16a).

The clay should be hollow for firing and should be of even thickness. To hollow a head sculpture for firing, cut it in half with a wire clay-cutter. Avoid the ears if possible. Lay the two halves on a piece of foam to avoid damaging the features (Figs 2.16c and d).

Figure 2.16a

**Figure 2.16
Preparing a head
sculpture for firing**

Figure 2.16b

Figure 2.16c

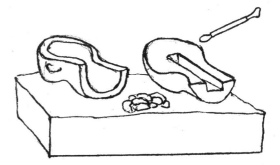

Figure 2.16d

Scoop clay from the inside of the head sculpture until it is 1″ (2½cm) thick all over (Fig. 2.16d). Put your other hand on the outside of the clay to test the thickness. Avoid making the clay too thin or it may collapse. Some areas like the neck may need extra clay to reinforce the sculpture: this will be in areas where the wooden post has left an impression. Press the new clay into these parts well. Stab the clay with a piece of wire every ½″ (1 cm) to release any trapped air. The wire should almost pass to the outside edge. Any holes that show on the outside can be repaired later.

To join the two halves: score the edge of the seam with a fingernail to make a key in the clay (Fig. 2.16e). Make some 'slip' with clay and water (you can mash the two together with a fork until it is a creamy consistency). Spread the slip over both seam edges and join the two parts of the sculpture.

Figure 2.16e

Press the seams well until the slip oozes from the joint: this will ensure that there is no trapped air. Tidy the seam.

As an extra precaution, I prefer to remove a small groove of about ⅜″ (1cm) along the seam and replace it with a roll of fresh clay to ensure that the seam will not open up when the clay dries (Fig. 2.16f). The sculpture can be retouched where necessary. The clay should be slightly stiff for such procedures, but should not be too hard to cut and hollow.

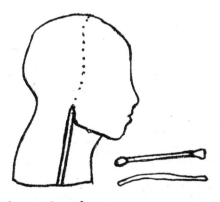

Figure 2.16f

Preparing a head sculpture for nylon-reinforced clay

The same method of preparing the bust peg for fired clay can be applied, that is, covering the wooden post with newspaper and tape for easy removal. However, you will probably want to add extra newspaper to reduce the weight of the final sculpture.

Screw up a few pieces of newspaper and tape them loosely to the bust peg. Cover the ball of taped newspaper with a thin layer of nylon-reinforced clay and allow to harden. This will provide a good basis for the head sculpture. Make sure that the ball of paper and clay is not too large or it may interfere with your design: 4″ (10cm) is a good size for the sculpture and is sufficient to allow the clay to shrink safely (Fig. 2.17a).

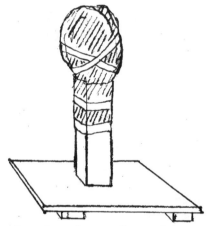

Figure 2.17a Preparing a head sculpture for nylon-reinforced clay

The nylon clay can harden slightly but do not leave it on the bust peg for drying totally. Even nylon-reinforced clay shrinks and will crack if it is impeded by the wooden post.

Another method of making a foundation for a head sculpture is with balloons, chicken wire and newspaper.

Blow up a balloon to a diameter of 4″ (10cm). Cover this with three or four layers of paper and glue, and allow to set overnight. Place the sphere of papier mâché over a tube of chicken wire and cover with newspaper

(Fig. 2.17b). Cover the whole framework with a thin layer of nylon-reinforced clay and allow to harden slightly. The head can now proceed on this base, but make sure that any future clay is kept damp while the sculpture is in progress.

When the head sculpture is finished it can be dried slowly. Remove any obstacles that will prevent the clay from shrinking as it dries (pop the balloon, for instance). The chicken wire could be snipped in places to allow for movement.

The clay can be painted with hardeners and baked if wished. It can also be painted with fake bronze, if that sort of finish is required.

Figure 2.17b

Some final words on nylon-reinforced clay

You may notice some wisps of nylon on the surface of the clay. These can be removed by burning them off with lighted matches.

If there are persistent cracks in the work when the clay is completely dry, fill them with epoxy paste.

Sculpture made with nylon-reinforced clay is not as good as that made with modelling clay or terracotta, however good the sculptor.

Abstract heads made from modelled clay

Once the fundamentals of head modelling are achieved and the proportions are learned, some experimenting with simplification or fragmentation of forms can be tried. The sculptor Brancusi honed down every detail in his head sculptures of Mademoiselle Pogany; there is little left of the features, but there is more than a gist of the character of the model.

Henri Gaudier-Brzeska's portrait of Horace Brodski (Plate 5) in the Tate Gallery collection has dramatic contrasts in tone, created by emphasising the planes in the face. The fragmented forms are a good example of Cubist sculpture; every part of the head has been given the same angular treatment, from the cheek bones and hair to the small areas around the eye.

There is an arrogance in the posture of the sitter, which was an attempt by Gaudier-Brzeska to convey some of the character of his friend, but the sculpture's real success lies in the sharp treatment of the forms.

These are just some heads that can be seen as a source of inspiration for making a head sculpture in clay. Other ways of tackling heads are discussed in the chapters on carving and direct plaster.

Recycling clay

Modelling clay and terracotta can be recycled by soaking in water. It is best to soak small lumps of hard clay no larger than a golf ball; soak these in a plastic bowl or bin for a couple of days or until the clay is saturated.

Pour off the excess water and put the clay out to dry. The professional method of drying out clay is to put it out on plaster slabs or 'bats'. These are only necessary for recycling large amounts of clay and small amounts (up to 15 kilos at a time) can be dried out on several newspapers covered with an old cotton sheet.

If the clay is spread thinly across the sheet, particularly in the sun, it will dry to the right consistency quite quickly. The clay can be turned easily by lifting the edges of the sheet. If the clay is turned and dried evenly, it will not need mixing, but if it is inconsistent, it can be kneaded or 'wedged' to mix it to a workable state. Wedging is a process used by potters to reconstitute clay. It involves slicing the clay with a nylon cutter and slamming the two halves together several times until the clay is well mixed.

Nylon-reinforced clay cannot be recycled.

3 | RELIEF SCULPTURE

Sculpture in relief differs considerably from sculpture 'in the round' in that it is generally attached to a back panel or matrix and is designed to be viewed from the front. Relief sculpture started as an extension of the art of drawing, and indeed, some would see it as a kind of three-dimensional drawing. Early reliefs were usually made as decorations for buildings and are of great importance, since they recorded scenes of life that would not have survived if just painted.

The Egyptian panel shown in Fig. 1.3 on page 5 is in shallow relief known as intaglio, where drawing is scratched into the surface of the stone.

There are many advantages in using relief as a way of making sculpture; it is easy to display by hanging on a wall, and complex designs can be achieved without any of the problems involved in making free-standing sculptures: reliefs are also easy to mould or construct.

Relief sculpture can be made out of virtually anything: clay, cement, wood, 'found objects', plastics, metal. Sculpting in relief can be a useful way of experimenting with materials and methods before trying more ambitious projects in the round.

Clay relief with pressed objects

You will need:

- a small bag of clay
- a 12″ (30cm) square, plastic-covered board
- household objects and textures for pressing

Roll out a 10″ (25cm) square of clay on a board with a rolling pin, or flatten it with the hand to a thickness of ¾″ (1½cm). Press objects into the clay: nuts and bolts, bottle tops, spanners, keys, pencils – anything with an interesting

shape. Press the objects to various depths; press in lines or in patterns. Try different arrangements until a satisfactory design appears. Neaten the edges with a knife and set square. The relief is now ready to be cast in plaster of Paris as described in Chapter 5.

The artist Eduardo Paolozzi used this method to create slabs which were assembled into robot-shaped figures in the 1970s. The objects chosen to be impressed seem to enhance the mechanical nature of the sculptures. Cesar Baldaccini's textured panels resemble a sculptural collage. They are often free-standing, large, and cast in bronze. Panels made this way can also be cast in cement or concrete for siting outdoors.

Clay relief using still life as a subject

You will need:

- paper or a sketch pad
- pencils or other drawing materials
- a modelling board or piece of scrap board
- 3kg bag of clay
- modelling tools or a blunt knife
- plastic bags for covering the clay and board
- objects for the still life composition

First arrange the still life; these can be made with the usual objects like fruit and wine bottles, or something more imaginative.

Draw the still life the same size as the intended relief: 8″ (20cm) square would be a good size to start with.

Cover the modelling board with plastic film or a bag to prevent the clay from drying. Roll the clay over the covered board to a thickness of 1″ (25cm); this can be done with a bottle or a rolling pin. Lay the drawing over the prepared clay and prick the lines through the paper with a nail or sharp pencil to transfer the image on to the clay.

Determine which areas will project and which will recede by either adding or digging out the clay. The effects of light and shade will be evident immediately. It is a good idea to prop the work up in order to plan the shadows; it also allows you to stand back and consider the work. Hammer a couple of large nails into the base of the modelling board to prevent the clay from sliding.

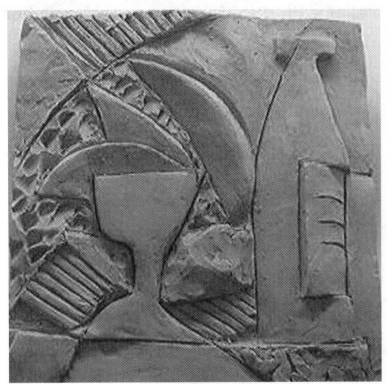

Figure 3.1 Clay relief: still life

The interpretation of the still life could be realistic, but it is more fun to simplify or abstract some of the forms and add texture. The sculptor Jacques Lipchitz produced a number of still life reliefs using 'Cubist' motifs. His association with other Cubist artists is reflected in his 'Still Life with Musical Instruments' of 1922 (Plate 2). Although, strictly speaking, the still life is essentially a painterly theme, it is quite clear that Lipchitz has interpreted the subject in purely sculptural terms. The planes and angles are accentuated by the light and shadows. There is a strong three-dimensionality in the projection of the different volumes and shapes.

Relief with drinking straws and matches

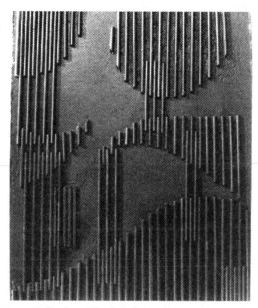

Figure 3.2 Relief with drinking straws and matches

You will need:

- a piece of scrap hardboard
- drinking straws
- scissors to cut the straws
- matches (with ends removed)
- impact glue
- paint

This relief can be made simply by drawing shapes on a board and cutting the straws to fit within the chosen lines. By spacing the straws evenly, further straws can be fitted in between to create shapes within shapes, adding interest to the design. A quick-drying glue such as UHU will fix the straws firmly, but do read instructions about what can be glued. Other materials that can be used for this project are balsa wood, small wood mouldings, dowel or gardening cane.

Simple geometric reliefs in chipboard or fibreboard

Figure 3.3 Simple geometric reliefs in chipboard

You will need:

- a sketchbook or paper and pencils for the design
- 1 inch (12mm) chipboard or MDF (medium fibreboard) and hardboard scraps
- a sharp saw for straight cuts
- a coping saw for curved cuts
- wood glue, sandpaper, paint

This relief is made from three 8″ (200mm)-square pieces of 1″ (12mm) chipboard. The vertical strips are ½″ (7mm) wide. The circular motif is made from a scrap of hardboard. All the elements have been stuck to square background with wood glue and painted with mid-grey emulsion. The varying tones have been achieved by the different proximity of the pieces.

To design such a relief, drawings can be made first, or a range of different-shaped pieces can be assembled until a pleasing design is achieved. Simple designs such as the one above work well in groups or clusters.

Relief on a theme of squares

You will need:

- a piece of square chipboard or MDF
- a length of square softwood moulding
- a sharp saw

- sandpaper
- wood glue
- a vice for holding the wood while cutting

Cut the moulding into cubes, triangles and rectangles. Arrange the shapes on the chipboard, and sandpaper the edges of the wood before gluing and painting. Try using different colours or black and white to accentuate the contrasts in the shapes. Cover some with silver foil. Experiment.

Study the works of Ben Nicholson, Victor Passmore and Mary Martin to see some excellent examples of this type of construction.

Some artists have used pre-formed shapes for their relief constructions, for instance, the American sculptor, Louise Nevelson and the French artist, Pol Bury. Both enclose their shapes within frames. Nevelson combined several structures into large assemblages that went beyond the scope of a wall hanging relief.

Many materials can be used for relief sculptures: plastic, mirror, string, architectural moulding, wire, 'found objects'; all can be assembled in imaginative designs and often with humorous results.

4 | CASTING AND MOULDMAKING: A ONE-PIECE MOULD

If a sculpture has been made in clay, it is unlikely to survive unless it is fired in a kiln or cast. Clay is a wonderful material for modelling, but is brittle and fragile when dry. A cast is a copy of an original sculpture that has been taken from a mould: this chapter will explain how to make some simple one-piece moulds from clay, using plaster of Paris and flexible moulds.

Casting is a process which requires a space that is not too precious, as it can be very messy. If there is access to a yard or part of a garden that can be covered in builders' plastic, mess can be contained and cleared by shaking the plastic into a dustbin or trashcan afterwards. It is best to cast outside in reasonable (i.e. not freezing) temperatures.

Making a plaster positive from a clay negative

Take the pressed clay panel in the previous chapter. The clay should still have been kept damp and soft for easy removal from the plaster.

You will need:

- a small bag of plaster (7lb or 3kg)
- a small flexible plastic bowl for mixing (1 pint or ¾ litre)
- water
- 2kg clay for walling and rolling pin, or
- 4 pieces of wood baton and 4 angle irons
- plasterers' scrim or bandage
- a sheet of builders' plastic film
- a bucket of water for washing hands and bowls

First prepare the area to work in. One edge of the large sheet of plastic can be tacked on to a wall and the rest spread over the table or bench and on to the floor. This should protect against any spillage or disaster.

Method 1: making a clay wall

Place the relief, still on its plastic-covered modelling board, on the workbench or table. Roll out the clay to a thickness of ¼″ (25mm) and cut strips 1½″ (35mm) wide and 10″ (255mm) long. Make a frame to fit tightly around the clay relief. Pinch the corners of the clay to secure them together, and press down the outside edges to the modelling board with your thumb (Fig. 4.1).

Figure 4.1 Method 1, casting: clay wall

Method 2: making an adjustable (and reusable) frame

Take 4 batons of 2″ × ¾″ (5cm × 2cm) wood 18″ (46cm) long and screw angle irons on to one end of each, leaving a gap of ¾″ (2cm). These will provide an adjustable frame for further use.

Figure 4.2 Method 2, casting: making an adjustable frame

Place the clay relief on a plastic-covered board on the bench, and fit the wooden frame around it tightly. If the clay piece is not quite 'true' at the edges and angles, some adjustments can be made to the design at this stage. Press a little clay around the base of the frame and also the corners, to plug any possible leaks. Everything is ready for the plaster (Fig. 4.2).

How to mix plaster of Paris

Do use plaster of Paris, not builders' plaster, as the two are quite different. Take equal volumes of plaster and water: if there are two identical containers for measuring this, so much the better (Fig. 4.3).

Figure 4.3 How to mix plaster of Paris; take equal volumes of water and plaster

Sprinkle the plaster on to the water until it sits in small peaks on the surface of the water and all the measured plaster has been used, then stir (Fig 4.4).

DO NOT STIR while the plaster is being added; it is unlikely to set. When the mixture is the consistency of cream, it can be poured into the frame and over

Figure 4.4 Mixing plaster of Paris: sprinkle the plaster on the water until it sits in small peaks

the clay pressing. Tap the table or shake the modelling board to agitate the plaster and ensure any trapped air bubbles rise to the surface.

It may take a few tries to mix perfect plaster: if the mixture is too thin it will be weak, and thick plaster will not run into the details and so should not be used. In either case, do not pour plaster down the sink: pour it into a rubbish bag (with plenty of newspaper to absorb the moisture). Wash hands and utensils in a bucket of water.

While the plaster is setting, cut a couple of strips of scrim and lay them on the surface of the plaster: this will give added strength. A couple of loops of wire could be fixed to the back for hanging the plaster panel later (Fig. 4.5): these should be fixed in place with scrim.

The plaster will become quite warm while setting; the fresher the plaster, the warmer the temperature. When it cools (in about half an hour), take away the clay wall or frame. Turn the work with the board upside down, and lift it away gently. This should be easy if the board has been covered with plastic film. The clay can then be peeled away from the plaster – it must be done while the clay is still soft. If the clay has been allowed to harden, soak the mould in water overnight so that the clay can soften and fall away. Care will be needed if there have been objects pressed quite deep into the clay. These will protrude more in the plaster and are likely to be broken as the clay is lifted from the plaster.

The plaster can be cleaned under the tap and stubborn bits of clay can be removed by some gentle scrubbing with a soft toothbrush. It can then be left to dry for several days before painting.

Casting a relief using the wastemould method

You will need:

- plaster
- water
- a bowl
- scrim
- walling material
- some ready-mixed watercolour
- a small bag of ready-mix cement and sand OR

- ■ ciment fondu and glassfibre for the cast
- ■ some motor oil or parting agent (see pages 69 and 71)
- ■ rubber gloves

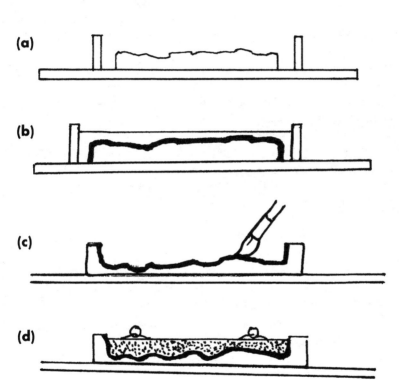

Figure 4.5

(a) Make a frame leaving 1″ or 2.5cm clearance round the relief sculpture

(b) Pour the coloured plaster over the clay relief, then add 2 or 3 further layers of plaster

(c) The dry mould is painted with motor oil

(d) Filling with cement and sand

Take the still life relief made in Chapter 3. Make either a clay wall or wooden frame, but this time allow 1″ (2½cm) clearance around the relief sculpture (Fig. 4.5a). It is essential to keep the clay soft for wastemould casting. If the clay has hardened, use the method described on page 54.

Measure small amounts of water and plaster: about ⅓ pint (170cc) of each. Put ½ teaspoonful of watercolour into the water and mix before adding the plaster. This will make a coloured layer of plaster to identify the mould from the filling material.

Pour the coloured plaster over the clay relief. If there are some deep areas in the design, it may be necessary to blow the plaster over the clay. A little agitation of the modelling board will release any trapped air. This first layer is known as the eggshell coat, and it is important in taking up all the detail from the clay relief.

Another bowl of plaster is mixed: about ¾ pint this time, and poured over the first. A third layer may be needed: it is important that the mould is not too thin: 2cm is ideal. The most vulnerable areas are the edges, so, if nothing else, make sure these are thick enough (Fig. 4.5b).

When the plaster has set, remove the wall, turn the work as before, take away the modelling board and gently peel away the clay. Wash the plaster mould and leave to dry for a few days.

The dry mould is painted with a thin coat of motor oil (do not use linseed oil for this). Soak the mould in a bowl of water or sink for several minutes, and wash off any excess oil (Fig. 4.5c).

Prepare the cement and sand mix – the amount to be made can be measured approximately by filling the mould with water and pouring this into a mixing bowl. The cement and sand can be added to the water and mixed to the right consistency. This can be poured into the mould, agitated and left to set with some strips of scrim or glassfibre laid on the back for extra strength. Wire rings are attached at this stage if the panel is to be hung (Fig. 4.5d), and the mould and contents can be covered in plastic film to ensure slow setting and greater hardness. It is left covered for a few days before the mould is chipped out (see page 54).

A lighter method of using cement is to laminate the mould with a fine casting cement called ciment fondu. The mould is oiled and soaked as before, then painted with a coat of ciment fondu mixed to a creamy consistency to fill all the details. If the mould can be seen through this first coat, another should be applied.

Equal parts of ciment fondu and sand are mixed to a stiff consistency and pressed into the mould with the fingers to make an even layer of between ½cm and 1cm. Scrim or glassfibre can be pressed into this layer for extra strength. The edges of the panel need to be fairly substantial, but the cast does not need to be solid. Indeed, ciment fondu should not be solid, as the curing process will generate heat and it could combust if made too thick or not mixed with enough sand. Use rubber gloves when handling glassfibre.

Ciment fondu can be used without sand, provided it is reinforced with glassfibre. Make sure that two coats of the ciment fondu are painted in before the glassfibre is added, or it will show through the cast. The glassfibre should be teased open so that the fibres are not too dense for the cement to soak through. Laminate the mould with three or four layers of glassfibre and ciment fondu, making sure that each layer is well soaked. Mix another batch of cement and glassfibre to a stiff consistency, and pack this around the edges to strengthen the cast. The cast panel can be quite thin: about ¼″ (½cm) provided there is plenty of glassfibre. Never fill a mould with solid ciment fondu unless it has sand or another aggregate to stop it overheating while curing (Fig. 4.6).

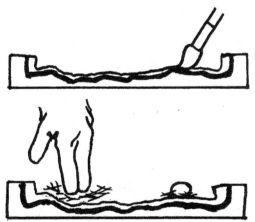

Figure 4.6 Filling a mould with ciment fondu and glassfibre

The filled mould should be placed in a plastic bag and left for 3 days before chipping out. Cement needs to cure slowly, so a wet mould and airtight bag will ensure that moisture is retained for successful setting.

To chip out a wastemould, you will need an old chisel and mallet. Turn the work upside down and hit away the edges of the plaster mould with the mallet. Try to avoid hitting the cement. When the edges are removed, turn the work over and cut away the plaster as shown in Fig. 4.7, holding the chisel at right angles to the mould. Work from the edge where the cement can be seen; it is inadvisable to chisel blindly in the middle or the cast can be damaged. There will be some warning of the proximity of the cast because of the coloured eggshell layer in the mould, but it is best to be systematic about chipping out. The oil or parting agent should help the plaster break easily from the cement cast, provided there is not too much texture or too many undercuts.

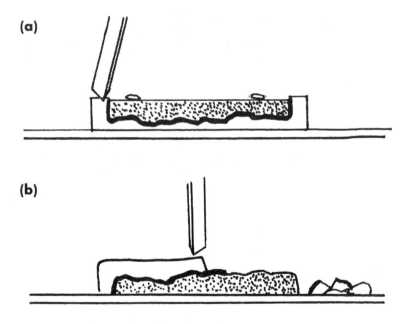

Figure 4.7 Chipping out a plaster wastemould:
(a) Start at the edges to expose the cement cast
(b) Work down at right angles to chip out the rest of the mould

Casting a relief using a silicone rubber skin mould with a plaster jacket

You will need:

- plaster
- water
- bowls
- scrim
- newspaper
- 500g silicone rubber (Moldsil, RTV-420, Por-A-Mold, Smooth On are some)
- catalyst and thixatropic agent
- an old (clean) tin or calibrated cup for mixing the first layer
- a calibrated syringe and weighing scales

Before embarking on mouldmaking with silicone rubbers, it is as well to buy a small booklet from the supplier on handling the materials and curing times. This project is an easy introduction to rubber moulds, which have enormous advantages over wastemoulds. They are easy to remove from the cast and can be used for multiple copies.

First, read the instructions on setting and curing times: some silicone rubber sets quite fast once the catalyst is added; others have about two hours' pot life and take six hours to cure. I prefer slow-setting silicone rubber because, although it may take longer to set, it is more relaxing to use.

Pour one-third of the rubber mixture into an old tin with one-third of the catalyst. Weigh the tin first so that measurements can be accurate, or use a calibrated cup made for the purpose. This is important as the catalyst is generally added to the rubber mixture at a ratio of 1:20 or 5%, which must be measured accurately with a calibrated syringe (Fig. 4.8a).

Use an old but clean paintbrush to paint the clay with the well-mixed, catalysed silicone rubber moulding compound. The clay can be stiff or even hard for flexible moulding; indeed it is less likely to damage when painting on the rubber. The brush will be useless after this!

The silicone rubber should be free-flowing and will find its way easily into all of the detail in this first layer. Add a few drops of the thixatropic agent (between 1% and 5%) to the remaining rubber, and stir. The silicone should thicken to a spreading consistency. Be cautious: too much will

Figure 4.8 Casting with silicone rubber and a plaster jacket

waste the material; the idea is to thicken the silicone rubber sufficiently to spread with a spatula or trowel. If there are undercuts in the design, it may be necessary to build up extra layers of rubber in these parts to avoid the plaster jacket catching in the undercuts.

The rubber mould will need to cure for one or two days at room temperature before the next stage (depending on the make). Since this is a skin mould, it will need to be supported by a plaster jacket. To make the jacket, tear some newspaper into 10cm squares. Mix about one pint (600ml) of plaster of Paris and dip pieces of newspaper into the plaster. Place a layer of plaster-soaked newspaper loosely over the rubber-covered relief; this will ensure that the plaster jacket will not be too snug and cause difficulty in removal from the rubber mould (Fig. 4.8b).

Add plaster until the jacket is 1″ (2½cm) thick; it may take two or three bowls of plaster to do this. The plaster jacket can be reinforced with scrim for extra strength. When the plaster jacket is completely dry (30–45 minutes), lift it off the rubber mould. The rubber skin can then be peeled off the clay original and laid inside the jacket.

The newspaper layer should make it easy to remove the jacket from the rubber mould, but if it does catch, turn all the work upside down and take out the clay – in pieces if necessary. File away any areas of the plaster jacket that might have undercut the rubber skin mould.

Always store the silicone rubber skin moulds inside their plaster jackets when they are not in use, or they will distort. Some mouldmakers even fill their empty moulds with sand to ensure they keep their shape.

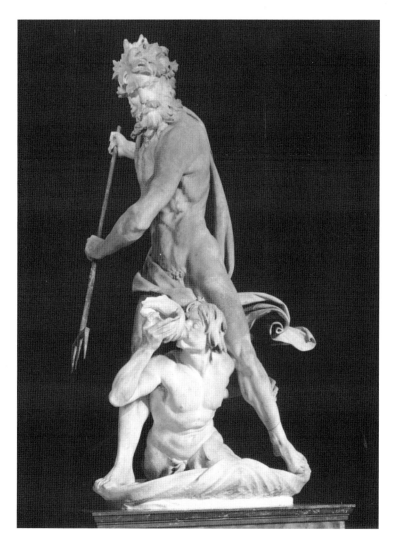

Plate 1 Bernini. Neptune and Triton. Courtesy of the Victoria and Albert Museum.

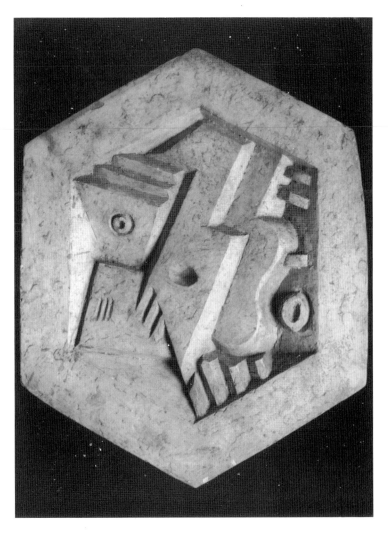

Plate 2 Lipchitz. Still Life with Musical Instruments, 1924. Courtesy of the Trustees of the Tate Gallery.

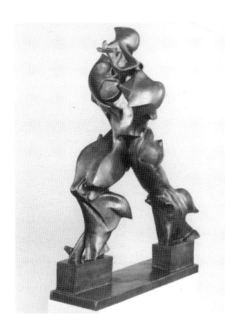

Plate 3 Boccioni. Unique Forms of Continuity in Space, 1913.
Courtesy of the Trustees of the Tate Gallery.

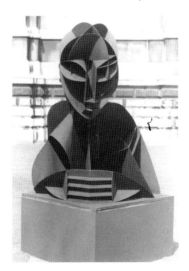

Plate 4 Head No. 2, 1916. The works of Naum Gabo © Nina
Williams. Courtesy of the Trustees of the Tate Gallery.

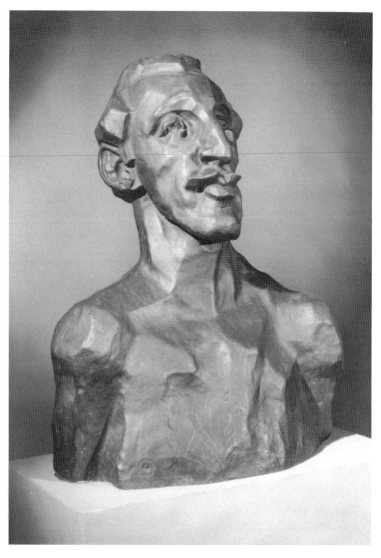

Plate 5 Gaudier-Brzeska. Portrait of Horace Brodski, 1913.
Courtesy of the Trustees of the Tate Gallery.

Alternative, reusable rubber mouldmaking method

These moulding materials (Gelflex, Vinamold) have to be melted at controlled temperatures in special melting pots or they will burn and give off highly toxic fumes. Vinyl should be melted outside or in a well-ventilated area; fume masks are recommended. Read a Vinamold instruction booklet before using these materials.

You will need:

- 1kg soft Gelflex or Vinamold
- a special melting pot and thermometer
- plaster
- clay
- a rolling pin
- newspaper

Melting vinyl can take some time. It is a good idea to start melting the material while other preparations are made for this process.

The clay relief can be wet or dry. Cover it with a sheet of damp newspaper. Roll out some clay about 1cm thick to cover the relief over the newspaper. The clay should extend at least 1″ (2½ cm) beyond the sculpture as shown (Fig. 4.9), with a ridge of clay placed 1cm from the edge. It is worth taking trouble to do this neatly.

Figure 4.9 Casting: covering the clay relief with newspaper and clay

A pouring system is made with clay. Make a funnel and vent on the two highest points of the relief. The work is now given a substantial plaster jacket; it can be reinforced with scrim. The top of the jacket should be flat (Fig. 4.10).

Clay vent Clay roll to make a pouring system

Figure 4.10

The plaster jacket is gently prised off and the clay and newspaper removed. Put the plaster jacket back over the clay relief: there should be 1cm gap between the model and the plaster jacket. A little adjustment may be needed to centre it over the relief sculpture.

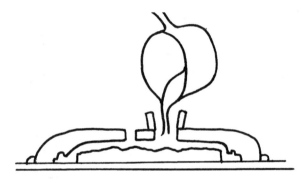

Figure 4.11 Remove the clay and paper. Replace the plaster jacket over the original clay relief. Pour in vinyl moulding compound

Use rolls of clay to seal the edge of the plaster jacket and press down well (Fig. 4.11). Make an additional funnel over the larger pouring hole and pour in the melted vinyl. Keep pouring the vinyl until it rises at the vent. Leave to cool completely before opening.

Cut off any excess vinyl from the top of the mould for easy removal and turn the mould over to remove the clay. The vinyl should slot neatly into

a groove in the jacket for perfect alignment. Clean out any clay residue; the mould is now ready for filling.

Both silicone and vinyl moulds can be filled with a variety of materials: plaster, cement, resins and casting paper. They do not need a parting agent and can be re-used many times if care is taken when they are peeled from the cast. Plaster can be released within half an hour but allow at least 2 days for cement. Resins should only be used outside as they are highly toxic.

If multiple copies are to be made of a sculpture, it is as well to number each cast as it leaves the mould and to set a limit on the number of copies made. The mould will probably tear after a dozen times anyway, but any potential buyers of the work will be reassured if they are investing in one of 'a limited edition'.

5 | CASTING AND MOULDMAKING: A TWO-PIECE MOULD

Why are moulds made?

Two-piece moulds are necessary for sculpture made in the round, and are more tricky than the simple one-piece moulds used for relief sculpture. They are necessary when a sculpture has been made out of ordinary modelling clay that is not to be fired, and whenever armature wire has been used.

To understand the casting technique using a wastemould, make a very simple, round shape in clay, like a ball or an apple. Draw round the highest point of the shape to mark where the seams are to be made on the mould. Prepare a wall for the seam.

Walling for seams can be made in two ways: one with brass shim and the other with clay. The advantage of using brass shims or fencing is that both parts of the mould can be made at once because the shims are left in the mould for the whole mouldmaking process. It is therefore quicker. The disadvantage of using brass shims is that they leave a rough edge on the seam line, which will need tidying afterwards.

The disadvantage of using clay walling is that only one side of the mould can be made at once, therefore the mouldmaking takes longer; but the advantage of clay walling is that the seam mark will be neater, and therefore need little, if any, repair.

Try both methods with these small experiments and weigh up the advantages and times they take. Both will be described separately. Keep the clay soft and wet for the casting process; if the mould is not to be made immediately, wrap the clay model in polythene until ready for mouldmaking.

If you are casting at home, a work area should be covered with builders' polythene to minimise the mess. Always mix a small amount of plaster at a time; it can set quite fast, particularly if it is old. The plaster can be mixed in margarine pots or microwave trays if you do not have rubber

plaster bowls; they have the advantage of being flexible for easy disposal of plaster. They are also free. It is quite a good idea to have two bowls to hand for casting, to avoid constant cleaning. Never rinse plaster bowls in the kitchen sink: rinse them in a bucket of water and allow the plaster to settle overnight. The surface liquid can be poured away and the residue can be scraped into a wastebag.

You will need:

- a small bag of clay
- 5kg plaster of Paris
- brass shim (if available)
- readymix watercolour or powder paint
- soft soap
- water
- a large sheet of builders' polythene
- scissors
- an old chisel or scraper
- plaster mixing bowls (or microwave trays)
- a large bowl for soaking
- a bucket for rinsing hands and plaster bowls which will save ruining the plumbing

Method 1: making a two-piece mould using shims

Cut the shims into 1¼″ or 3cm squares (Fig. 5.1a).

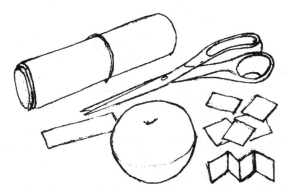

Figure 5.1a Making a two-piece mould using shims

Push the shims into clay along the marked line; they need only to go in $\frac{1}{4}''$ or $\frac{1}{2}$ cm. Make 'keys' at two points. This is done by bending a longer piece of shim into a V shape to create notches in the mould to lock the two halves (Fig. 5.1b).

Neaten the edges of the shim wall with scissors as shown.

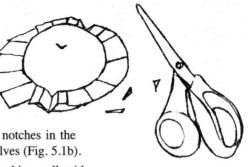

Figure 5.1b

Figure 5.1c

A pouring duct is made out of two half rolls of clay and attached to the model on either side of the shim wall: make it substantial, as it will need to hold the model for plastering (Fig. 5.1c).

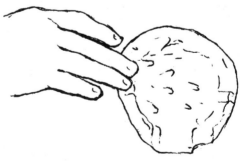

Figure 5.1d

Place the model on a board for easy turning. Put ½ teaspoon of readymix watercolour or powder paint into ¼ pint of water and sprinkle an equal volume of plaster on to the coloured water, stir until smooth and creamy. Flick the plaster on to the model (Fig. 5.1d).

Flicking plaster is a knack; it can be done with a large paintbrush, but unless you are scrupulous over cleaning up immediately, hands are best. Cup the fingers in the plaster and throw the plaster at the model in quick flicking movements, taking care not to touch the clay. The first, coloured or eggshell coat of plaster should be ⅛″ or 2mm thick, and its function is to make the mould discernible from the cast, particularly if the cast material is also plaster. Turn the model around on the board to make sure all the clay model and shims are covered.

Mix some more plaster: about ¾ pint, without colouring agent. This needs to be slightly thicker in consistency: if it appears too runny, wait a minute or two until it thickens. Don't add more plaster: it may fail to set.

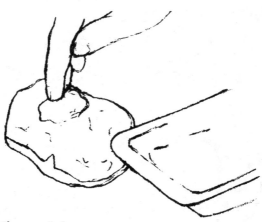

Figure 5.1e

The thicker layer of plaster can be spread with the hand or a spatula all over the model and on either side of the shims, but make sure the shim tops are not obscured. The seam must be obvious, and to make sure, run a chisel or knife along the seam line until the shim edges are revealed (Fig. 5.1f). The plaster mould should be between ½″ (12mm) and 1″ (25mm) thick, particularly along the seam.

Soak the mould in a bowl of water for an hour, or longer if the clay model is slightly hard. The mould may open on its own due to the expansion of the clay in water, but if not, it can be gently tapped with a chisel along the seam line (Fig. 5.1g).

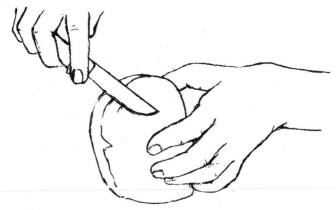

Figure 5.1f

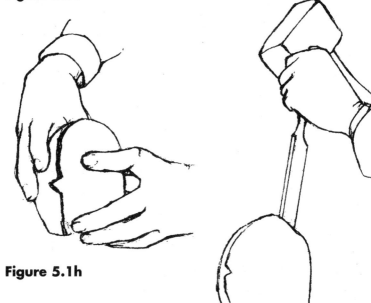

Figure 5.1h

Figure 5.1g

Prise the mould gently but do not put too much pressure on one area alone: it could fracture (Fig. 5.1h and i).

Remove the shims: they can be oiled and reused. Take out the clay – it should be easy to remove from such a simple shape – and wash the plaster mould with a soft brush or toothbrush. If the mould is not to be filled immediately, tie the two halves together with string or scrim to prevent warping. They should lock together in the notches made with the shim wall.

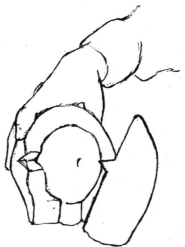

Figure 5.1i

Method 2: making a two-piece mould using clay walls

You will need:

- all of the items used in Method 1, plus
- a rolling pin
- two batons of wood ¼" (½cm) × 1" (25 cm) × 14" (35cm)
- some Vaseline or petroleum jelly

To make perfect clay walls, roll out a strip of clay between 2 batons of wood placed 1" or 25cm apart (Fig. 5.2a).

Clay walls can be made without batons, provided they are of an even thickness.

Figure 5.2a Method 2: using clay walls

Encircle the model with the clay wall at its widest part and press on well. Make some buttresses to provide additional support as shown (Fig. 5.2b).

Add a pouring duct by laying a roll of clay on the wall: this may need additional support from underneath.

Push a finger into the clay wall in 3 or 4 places to make locating 'keys' (Fig. 5.2b).

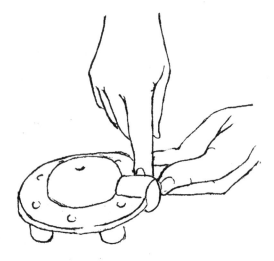

Figure 5.2b

Apply the plaster as in Method 1, using a coloured eggshell coat (Fig. 5.2c) and the thicker topcoat (Fig. 5.2d). Leave the plaster to set. This takes about 10–15 minutes. Test the temperature of the plaster to check: it should warm while it is curing.

Figure 5.2c

Figure 5.2d

Turn the mould over and remove the clay wall (Fig. 5.2e), but leave the clay pouring duct in place.

Spread a thin layer of petroleum jelly along the edge of the plaster wall (Fig. 5.2f).

This will prevent the two halves sticking together. If no petroleum jelly is available, motor oil and a thick smear of clay wash will do.

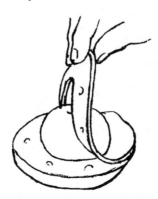

Figure 5.2e

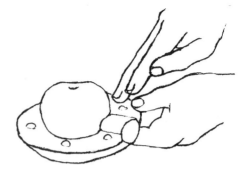

Figure 5.2f

Proceed with the process by repeating what was done on the first side, but make sure that the plaster does not drip over the seam by clearing the edge constantly. The two halves should be roughly the same in thickness with extra plaster around the seam (Figs 5.2g and h).

Figure 5.2g

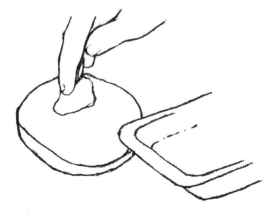

Figure 5.2h

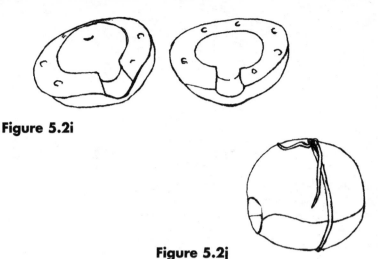

Figure 5.2i

Figure 5.2j

The model and mould can now be soaked, separated, washed and tied (Figs 5.2i and j). It would be interesting to note the times taken for these two different methods.

Filling wastemoulds with plaster

The wastemoulds can be filled with a variety of materials, but as these are an exercise, it will be cheapest to fill them with plaster of Paris. A parting agent is used so that the mould does not adhere to the filling material. The parting agent for plaster is soft soap diluted in warm water (Fig. 5.3a). This can be bought from a sculptors' shop or a chemist but, if necessary, a bar of bathroom soap can be frothed with a paintbrush and painted into the mould. A wet mould will not absorb much soft soap but a stored, dry mould will need plenty of soaping and soaking. Plaster moulds must be saturated before filling with either plaster or cement.

The two halves can be joined with string or scrim. Mix a small amount of plaster (¼ pint) and spread this round the seam to prevent leaks (Fig. 5.3b).

Prop the mould in a bowl with the pouring duct face up and secure in an upright position with lumps of clay (Fig. 5.3c).

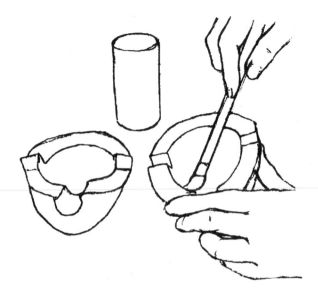

Figure 5.3a Applying a parting agent, joining the mould and filling with plaster

Figure 5.3b **Figure 5.3c**

Mix some plaster to a liquid consistency and pour it into the upturned mould. The amount of plaster that is needed can be gauged by filling the mould with water and pouring it into the plaster mixing bowl first, before adding plaster (Fig. 5.3d). Pour the mixed plaster into the mould and tap it to free any air bubbles. Leave to cure.

Figure 5.3d

Filling wastemoulds with cement and sand

You will need:

- a small bag of cement and sand (readymix, or mix your own to a ratio of 1:3)
- motor oil
- a paintbrush
- plastic mixing bowls

There are several parting agents that can be used for cement: soft soap is one, but a motor oil is preferable. This should be applied when the mould is fairly dry and therefore absorbent. A light coat of oil is needed: too much must be rinsed out. Linseed oil must not be used.

Old-fashioned shellac is also an excellent parting agent, but the mould has to be completely dry before application. Several coats are applied of shellac diluted with methylated spirit. Avoid using shellac that is too thick: it will clog the detail in the mould.

When the parting agent has been applied, the mould is tied together and soaked in water. A mould that has dried out completely may take ten minutes

to saturate, and a good indicator of saturation is when air ceases to bubble from the plaster. Take the mould out of the water, open it, and wipe out any excess oil with tissues. Tie the mould and plaster the seam.

Mix the cement and sand with water to a pouring consistency and fill the mould. Take a stick, wire or pencil, agitate the cement mixture with a prodding action to ensure air is not trapped in the mould, and leave to set in a plastic bag to retain the moisture. The cement-filled mould should not be touched for at least two days (ten days if using Portland cement). Cement needs to cure slowly: the longer it sets, the harder it gets.

Cement should not be used on its own when filling a mould solid: it generates too much heat when curing and can combust. If a solid cast is required, mix cement with sand or another aggregate in a proportion of 1:3. An alternative method of filling a mould with cement is to laminate the mould with glassfibre or scrim, which has been discussed on page 53. This method is ideal for light, hollow casting and is particularly suitable for large pieces of sculpture. Ciment fondu is ideal for this purpose.

Ciment fondu moulds are filled in their separate parts (Fig. 5.5). After oiling, soaking and filling the mould parts, make sure that the edges of the seam are clean. The mould should then be left open overnight to set, covered in wet newspaper and plastic bags. The next day, the mould is reassembled, tied and plastered along the seam, ensuring correct alignment.

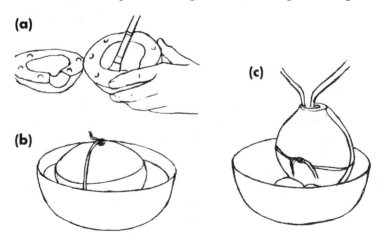

Figure 5.4 Filling a mould with cement and sand: (a) oil; (b) soak; (c) pour

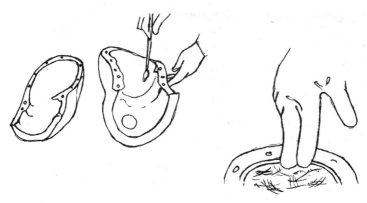

Figure 5.5 Filling a two-piece mould with ciment fondu and glassfibre

Mix some ciment fondu, sand and glassfibre to a stiff consistency and press this along the inside seam (Fig. 5.6). If your hand does not reach inside the mould, pour a more liquid mixture along the seam and roll the mould to ensure all the seam is covered. Leave the ciment fondu to set in plastic bags for at least two days before chipping out the mould.

Figure 5.6 Pressing ciment fondu and glassfibre along the inside of the mould

Chipping out a wastemould

You will need:

- a blunt chisel
- a mallet
- an old cushion or a piece of foam to hold the mould

Place the mould on the cushion and tap the chisel along the seam until the mould starts to break away (Fig. 5.7a).

Figure 5.7a Chipping out a plaster wastemould

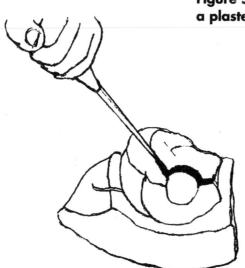

When the cast is exposed (Fig. 5.7b), hold the chisel at right angles to the mould and tap downwards, chipping away a little of the mould at a time (Fig. 5.7c).

Figure 5.7b

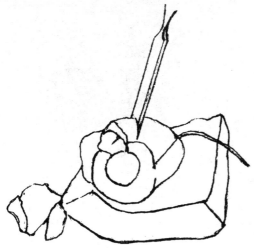

Figure 5.7c

Be cautious when approaching the coloured layer. The parting agent should make the mould separate easily, and if the cast is simple with no undercuts or protrusions, it may break away in two or three large pieces (Fig. 5.7d).

Figure 5.7d

A more complex cast will need reinforcement with scrim or a stronger material than plaster.

The pouring duct can be chipped away and the plaster cast finished with a chisel or rasp (Figs 5.7e and f).

Figure 5.7e

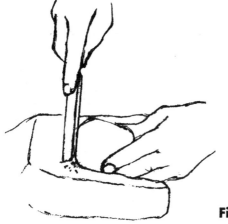

Figure 5.7f

Plaster takes several days (even weeks) to dry completely. When it is dry, it can be finished with sandpaper and prepared for painting if wished.

Making a two-piece flexible mould

For this method of mouldmaking, a real apple is used rather than a clay model, but clay will be needed for walling as before.

You will also need:

■ a box (this can be made of children's plastic building bricks: Lego is ideal)

■ a pourable moulding compound
■ a measuring cup
■ a can of release agent

The moulding material may be a hot-melt type such as Vinamold or Gelflex or silicone rubber. A hot-melt mould can be reused, but needs to be melted carefully at controlled temperatures. A mould made from silicone rubber cannot be recycled and, as it is expensive, should only be used for sculptures that merit the expense.

If you are using a hot-melt material, allow plenty of time for melting: it can take hours. If you are using silicone rubber, measure the quantity to be used for each side in a calibrated plastic or paper cup, but do not put the catalyst in until the last moment. Some silicone rubbers cure very fast (within minutes); always read instructions on the label.

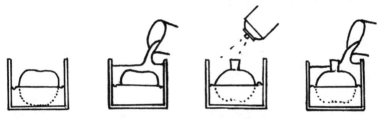

Figure 5.8a–d Making a flexible mould

Sink the apple into some soft clay inside a box. The clay should reach the widest part of the shape, otherwise an undercut will form in the mould (Fig. 5.8a). Press a finger or pencil into the clay in five or six places to make 'keys'. Pour half of the moulding material over the form in the box and leave to set. Hot-melt moulding will set in an hour or so, but some silicone rubber may take up to 6 hours to cure (Fig. 5.8b).

When set, turn the mould with its shape upside down and remove the clay: it may be necessary to unpick the Lego box to do this. Replace the shape and half mould in the rebuilt box, and spray the mould edge with release agent (Fig. 5.8c). Place a roll of clay on top of the shape to make a pouring duct, and pour in the second part of the mould material (Fig. 5.8d).

The mould may be strong enough to keep its shape without the Lego box, but this will depend on the type of material used and the shape of the mould; some moulding materials slump more than others. Larger shapes

need to be supported by a plaster jacket, and the method for making this type of mould has already been covered on page 56.

There are several technical leaflets on casting and mouldmaking in different materials, and once you have understood basic concepts, it will be worth investing in more detailed reading.

Further reading

M. Sharp: *Plaster Waste-Moulding, Casting and Life Casting*
Cold Cure Silicone Rubber for Mouldmaking (no author stated)
Flexible Moulds with Hot Melt Vinyl (no author stated)
E. Folkard: *Casting in Ciment Fondu*

All these booklets are available from

Tiranti, 70 High Street, Theale, Reading, Berkshire RG7 5AR;
Tel: 0118 930 2775; Fax: 0118 932 3487

6 | SCULPTURE IN STONE

Stone sounds a daunting material to consider for sculpture, but there is a variety of 'soft' stones that are easy to carve, and a relatively small number of tools are required. Soapstone and white alabaster are attractive as well as soft; a small piece of sculpture in either of these stones can be completed in a few days if the design is not too ambitious.

Stone needs to be carved in the open air because of the dust it generates. I have done quite a lot of stone carving outside with little equipment, although having a robust bench or banker is a great advantage (Fig. 6.1).

– goggles
– face mask

Figure 6.1 Stone carving with minimum equipment

Holding the stone still while working on it is quite easy: all that is needed is a bag of builders' sand. Decant half of the sand into a large washing-up bowl and place the stone in the sand: this will hold it firm. Awkward shapes can be half buried when they are no longer flat. The remaining sand can be left in the bag to make a cushion for larger pieces that will not fit into the bowl.

Before investing in a piece of real stone, it would be as well to have a trial run with a cheap material to get the idea of reducing form by carving. Celcon and Thermalite are manufactured building blocks available from most builders' merchants; they are rather like 'Aero' chocolate in texture, so very easy to carve. A block measuring 8″ × 8″ × 16″ will cost less than £3 to buy – not a big investment to find out if carving is something you enjoy.

The other requirements may have been bought already: plasticine or clay, a crayon, a couple of old chisels, a carpenters' mallet and a Stanley surform or file.

Figure 6.2 Chisels, a mallet and Stanley surform

An old saw could also be useful for cutting away large areas from the block. The word 'old' is stressed for all these items; tools will soon blunt on this material, and someone who is keen on woodwork may not appreciate it if their chisels are ruined when borrowed for carving. If you are going to progress to carving stone anyway, invest in a couple of stone-carving chisels and a dummy mallet right away. They will last for ever, provided they are sharpened well. (See p. 106 on sharpening tools.)

Carving a shell or other natural object

First choose the shape. In this instance, choose an interesting (but not too complicated) shell that lends itself to an idea for sculpture. Make a few drawings of it from all views to become familiar with its shape and structure. The next step is to make a maquette in plasticine or clay: this is a small-scale model of the piece of sculpture, and will help with the realisation of the three-dimensional forms of the shell. Make the maquette no larger than 2½" or 6cm in any dimension, so that it can be easily manipulated with one hand.

When you are satisfied with the maquette, hold it in front of the block. Move it backwards and forwards until it seems the same size in front of the eye. Draw around the outline of one profile on one face of the block. It should be as easy as tracing, but may need a couple of tries to get the hang of it. I have found that it is helpful to close one eye when lining up the maquette and block.

Figure 6.3 Shell design for Celcon block

Once the outline is marked, the profile can be cut all the way through and large areas can be sawn. When chiselling, hold the tools the right way to chip pieces away from the block. If the chisel is held the wrong way up, it is liable to dig into the block and more will be removed than intended. Stone-carving tools do not cause this problem, since they have been designed for the job.

Figure 6.4 Holding the chisel for carving

Now draw the second profile. Hold the maquette over the top of the block and draw from above. Again, large areas can be sawn away before chiselling down to the finer lines of the sculpture. By now the piece of work may be taking on an irregular shape that is difficult to hold still while carving, particularly as the material is light. This is where a bowl of sand is needed to support the stone sculpture while it is carved.

Figure 6.5 Holding the carving steady in a bowl of sand

The third and last profile will remove the corners from the first two sides and join all the profiles together. Refer to the maquette constantly for this; it may even help to run your hands over it to feel the direction of the forms as they relate to each other. If the chisel is worrying to use at this stage, a surform will grate the block easily and leave a satisfying texture to the sculpture. The blade on the surform can be used either way: it can be pushed or pulled, depending on the way it is inserted in the handle. Spare blades can be bought cheaply.

The air bubbles in the block will fill with dust, and if you are a real purist, vacuum the sculpture when completed to ensure an even texture. The sculpture can be sealed with a mixture of PVA glue (Unibond or school glue) mixed with water to the ratio of 1:3. Simply brush it on and allow it to dry. This material does not look good painted; it is best to be honest about the material, and not disguise it as something else.

Apart from shells, exotic fruits and vegetables can provide useful sources for shapes in sculpture: peppers, physalis, poppy seed-heads, fir cones and other plant forms. The carver Peter Randall-Page has made many studies of plant seed-heads as a starting point for his large stone sculptures and Henry Moore's design studio had collections of natural forms such as flints, bones and bits of driftwood that were a constant source of inspiration and ideas.

Other materials such as chalk or plaster of Paris can be used to practise stone-carving before embarking on the real thing. To make a plaster of Paris block, pour mixed plaster into a cardboard shoebox or milk-carton, and allow to harden for an hour. The cardboard can be torn off afterwards. It is easier to carve the plaster while it is still damp, and a surform is excellent for grating the surface. Surforms can be used on wet plaster, but not files as they will clog and be ruined. Leave any filing until the plaster is completely dry, usually after a couple of weeks. (See Chapter 4 on how to mix plaster.)

Carving a seal in soapstone

When choosing soapstone, look carefully for any fissures or weak areas in the stone. A good quarryman or stoneworker will help select a piece, and it should not cost more than 70 pence per kilo (correct at the time of going to press). To do this project in the size suggested will cost between £8 and £10 for the stone. (Allow extra for delivery if you are ordering by post.)

Soapstone is an attractive stone, usually black in colour and speckled with grey, red and yellow minerals. (Australian soapstone is white with grey markings.) The minerals tend to make the stone brittle and soft, so carving is easy – so easy that care has to be taken not to remove too much at once.

For the seal design, look at some photographs of seals or make sketches in the zoo. Study the 'Seal' sculpture of 1943 by Constantin Brancusi, or perhaps look at Innuit soapstone carvings of seals. Choose a square or rectangular piece of stone, and mark it as illustrated.

Figure 6.6 Fitting the seal shape into the stone

Make a maquette as in the previous project. It will help to work out the shape and proportions of the sculpture. It might be useful to do this before visiting the stone supplier or ordering the stone; it will help in selecting the most suitable piece. Alternatively, the stone can be cut to exactly the right size, but there may be an extra charge for this. Suppliers of stone are listed in the 'Useful addresses' section.

Apart from the soapstone, you will also need:

- clay or plasticine for the maquette
- two stone-carving chisels (¾″ and ⅜″)
- a dummy mallet
- a bowl of silver sand
- safety specs
- crayons
- a stone rasp or a tungsten file
- waterproof abrasive paper

The dummy mallet comes in several weights: 1lb, 1½lb and 2lb. As a woman with small wrists, I prefer to use a one-pound mallet, although men usually choose the heavier types. Ideally, you should visit a shop that supplies these items and see how they feel in your hand. Most sculpture shops sell by mail order, and will change a mallet if the weight is wrong, but generally for these projects, I would suggest 1–1½lb mallets for women and 1½–2lb or heavier mallets for men (Fig. 6.7).

Figure 6.7 Stone-carving tools

Carving requires sharp tools, so a sharpening stone is an essential item for any sculptors' toolkit. (See appendix on p. 106.) Stone-carving tools need honing about every fifteen minutes while working on a piece of stone.

Copy the design from the maquette on to one side of the stone, as before. Cut the profile away from the line in fairly small pieces. Don't be too ambitious by chipping huge pieces away in an uncontrolled manner; the wrong piece may come away! (If it does, keep the piece and glue it on – resin glue works well on soapstone.)

When these sides have been cut, turn the stone and draw the profile from the top. Carve the form with the chisel almost to the drawn line. Use a file to finish the sculpture, once these two profiles have been cut, to remove any corners and sharp edges; soapstone is quite soft and easy to refine. Make sure that any small chip marks left by the chisel are removed.

If the shape looks and feels good, the stone can be finished with waterproof (wet and dry) paper. This is available from most hardware or DIY shops in a variety of grades. Buy three grades: one very coarse, one medium and one very fine. The grades of waterproof paper are measured in the number of grit particles per square inch, thus the higher the number, the more grit and finer the paper.

Put the sculpture in a half-filled bowl of water and rub the stone with the coarsest grade of paper. It will be easiest to work with 3″ or 7.5cm square pieces; rub the stone until all the file marks are removed. Move on to the medium grade, then the fine. As the stone is rubbed with the abrasive papers, the rich colours of the stone will be revealed.

To maintain this colour, a few coats of mineral oil are applied to the stonecarving. Liquid paraffin from the chemist is ideal as it is colourless, odourless, and can be applied liberally with the hands. Wax polish the piece a few days later to bring out the colour of the stone.

Carving a bird in alabaster

You will need:

- a piece of white or near white alabaster costing £12–£15 (the red alabaster is very hard, so avoid it to begin with)
- chisels
- a mallet
- files

■ crayons

■ waterproof sandpaper

Choose a piece of alabaster without too much colour in it for the first carving; the colour is usually a mud seam, and may cause a weak spot in the stone. Irregular shapes can be chosen for this piece and the design adapted

Figure 6.8 Dove sculpture: fitting the design into the block of stone

accordingly. The piece illustrated is based on an early Barbara Hepworth sculpture of 1927: 'Doves' (Fig. 6.8). Birds have provided many sculptors with inspiration; look at 'Doves' of 1914/15 by Epstein, or the more abstract sculptures in Brancusi's 'Bird in Space' series of 1925 onwards.

Alabaster, like any stone, needs very sharp tools; it needs to be cut rather than chipped, and it may be better to buy a new ¾″ wood chisel just for carving alabaster, if the stone chisels are not absolutely sharp. Wood-carving gouges are also excellent for carving alabaster but must be kept separately from those used for wood. Use a wooden mallet if using wood-handled tools: the general rule is to hit wood-handled tools with a wooden mallet, and hit metal-handled tools with a metal mallet.

Wood chisels do have the advantage of being available at the local hardware shop. Although they are ideal for alabaster, they will not be much good for harder types of stone.

Make the maquette or small model in clay or plasticine as before, and copy the shape by drawing it with crayon onto the stone. Cut away the surplus stone by holding the chisel as shown in Fig. 6.4. Care must be taken not to dig down with the tools because alabaster will 'bruise' if tools are punched at right-angles, leaving white marks that can penetrate up to ½cm. Lines have to be redrawn constantly as a reminder of where to carve.

Cut the stone a little at a time along the directions indicated, until the approximate shape is achieved. The stone will file easily, and can be finished in the same way as soapstone, with waterproof abrasive papers and one coat of oil. Alabaster should not need polishing; it will have an attractive translucency which is enhanced when displayed near a light.

Alabaster is soluble in water and not suitable for outdoor display. Due to the individual markings on both soapstone and alabaster, it is best to design simple shapes for carving these stones. Complicated shapes will interfere with marking; equally, too much detail in the form will be lost if the marks in the stone are too pronounced.

Carving limestone

Once you have the 'bug' for stonecarving, you may want to try a more challenging stone such as limestone. It is widely available in most countries: nearly 20% of the earth's landmass is made of limestone. The colour of limestone varies, depending on where it is quarried and the minerals present; for instance, the ochre tints of Bathstone and Ancaster

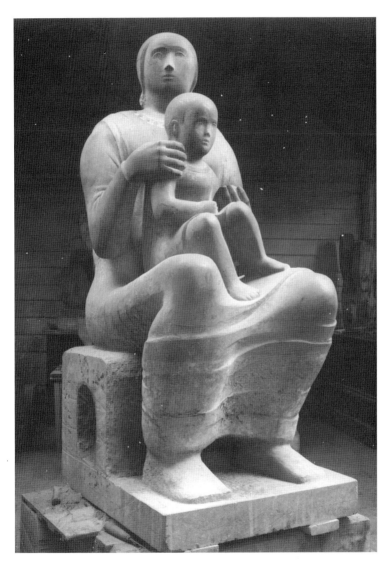

Plate 6 Henry Moore. Madonna and Child, 1943.
Reproduced by permission of the Henry Moore Foundation.

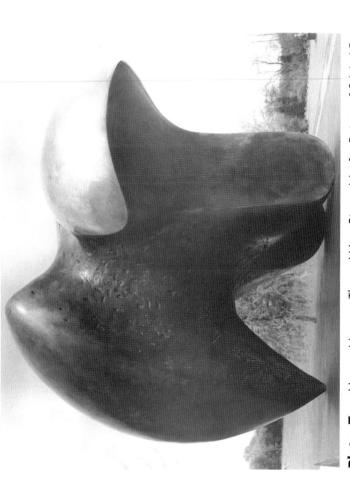

Plate 7 Henry Moore. Three Way Piece No.1: Points, 1964–65. Reproduced by permission of the Henry Moore Foundation.

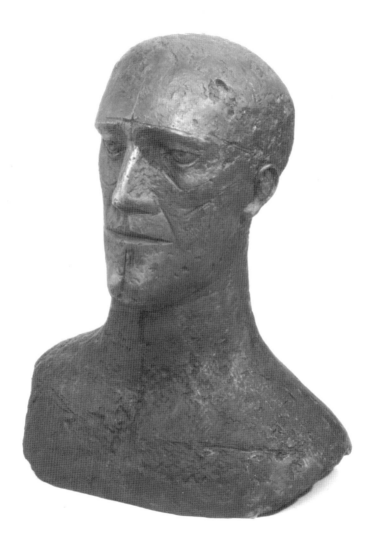

Plate 8 Elisabeth Frink. In Memoriam 1, 1981. Courtesy of the Trustees of the Tate Gallery.

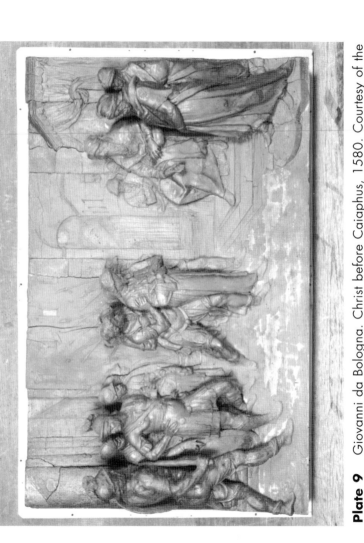

Plate 9 Giovanni da Bologna. Christ before Caiaphus, 1580. Courtesy of the Victoria and Albert Museum.

are due to the presence of iron oxides. White limestone from Portland is best known for its use in London buildings such as St Paul's Cathedral, the Bank of England, and many modern developments in London. American limestone tends to be grey in colour.

The evenness and close texture of basebed limestone make it an ideal stone for greater detail than is possible in alabaster or soapstone. Limestone gives the sculptor opportunities to experiment with surface textures, patterns and tones without cause for worry about intrusive marking from the material.

The approach to carving limestone and other harder stones needs to be systematic; it is essential to be equipped with the right tools. You may have already purchased your mallet and a couple of stone chisels for the soapstone project; for limestone you will also need a point or a punch, and a claw chisel. If tackling a large piece of stone, you might also want to invest in a pitcher, but this will not be necessary for a small carving; the largest flat chisel will do. Pitchers need a certain amount of brute force from a heavy hammer.

Figure 6.9 © Tiranti Ltd
(a) pitcher
(b) limestone point
(c) claw

To start the sculpture, the pitcher or a broad chisel is used to break into the smooth block. The point is then used to rough out the stone; it is held at about 45 degrees to the block and should follow the direction of the required form.

Alternatively, a punch can be used: this tool is slightly shorter than the point, and is used at right-angles to punch away the stone; this is a slower process than pointing, but a bit more controlled, as smaller pieces are removed at a time. The angle of the point or the punch tends to vary with the hardness of the stone: the harder the stone, the steeper the angle

needed to achieve the greatest impact. Limestone is not so hard as to need a vertical blow; a limestone punch or point tends to be longer than other stone tools, and slightly rounded at the end.

Figure 6.10a A broad chisel is used to break into the smooth block; the point is then used to rough out the stone

Figure 6.10b

Most of the carving and shaping is done with a point or punch. It is important, when pointing or punching across a piece of stone, to stop some way before the far edge; otherwise a large piece could break away. Instead, work back from the other side as illustrated in Fig. 6.10b. Do not work too close to the final surface with the point or punch; other tools will refine the sculpture.

The first refining tool is the claw chisel, which will smooth the rough marks made by the point. Sharp chisels will remove claw marks, although some carvers prefer to leave the texture as part of the finish. This method of stonecarving has been tried and tested since antiquity, though individual carvers may have their own preferred variations on the use of tools.

Carving a torso in limestone

Make a number of sketches from a life model or study the work of some sculptors who have specialised in the life model. The nineteenth-century French sculptor Aristide Maillol made many sculptures of women using massive, simple forms that would lend themselves well to a carving project.

The torso is an ideal shape for its compactness of form without too much detail. It is a theme that has been exploited by countless sculptors, no doubt inspired by damaged classical pieces.

You will need:

- a piece of basebed limestone 6″ × 4½″ × 12″ (or 15cm × 12 cm × 30cm)
- a dummy mallet
- a pitcher (optional)
- a limestone point or a punch
- a claw chisel
- 2 or 3 stone chisels of varying widths
- a sturdy bench that will withstand hammer blows (or a bowl of sand on the ground)
- clay or plasticine for the maquette
- a crayon

You may also need a stone file and a riffler.

Limestone will take a little longer to carve than alabaster or soapstone, so it is well worth taking extra effort with the design. Make a small maquette as before, or a clay model the actual size of the intended carving from which to take measurements with callipers or dividers.

Draw round the maquette and take careful measurements to mark up the stone. Use the pitcher or a large chisel to rough away the corners: this can be done on the flat surfaces of the stone. Use the point to remove the stone to within 1cm of the drawn line. As has been said before, it is a good idea not to take the point all the way to the far side; stop a couple of inches short and work back to avoid pieces breaking off unintentionally.

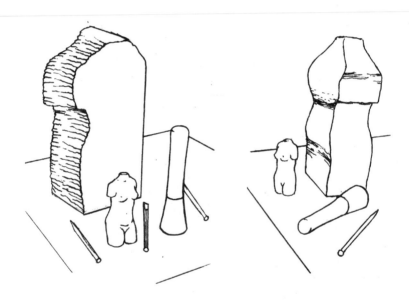

Figure 6.11 Carving a torso in limestone

The stone can be carved nearer to the intended surface with the claw to smooth the marks made by the point. Claw marks can be removed with a chisel and the carved edge can be filed to make the surface easier to draw the next profile. Carve through as before. The sculpture is nearly done.

The front and side profiles can be rounded with a claw; anything removed now has to be done with a great deal of control, subtlety, and with constant

reference to the clay model. Look from above and underneath to check the form. All remaining claw marks can be smoothed with sharp chisels and the whole sculpture filed.

Stone files can remove large amounts of stone when new and sharp. It is important to use them sparingly or the subtlety of the carefully carved forms can be lost. Small shapes and corners should be filed with a riffler (Fig. 6.12).

Figure 6.12 A riffler

To make rifflers and files last longer, use them only in a forward, pushing movement; if rifflers and files are rubbed backwards and forwards, they will wear out quickly. The expense alone will teach prudent use!

Limestone is finished with waterproof abrasive paper, but it is not necessary to oil or wax the sculpture. If left outside, a marble sealer should be used to prevent oil or grease from marking the stone, but otherwise it can be left as it is and washed occasionally. Sharp edges will weather over some years depending on the atmosphere, but otherwise it is a good stone for outdoor sculpture.

The projects suggested have been selected for simplicity of shape and ease in carving. All the shapes have been convex forms, and therefore preferable for manipulation of carving tools and ease of cleaning up and filing. Avoid designing shapes that have complex, concave forms; they are difficult to reach with stone-carving tools. Carvers like Barbara Hepworth made many abstract pieces with concave shapes, but there was usually a hole through which carving tools and files could pass; the holes made a pleasing element in the design, and also had a practical purpose. Deep hollows are difficult to deal with and are best avoided.

The nature of stone and the process of carving make thin, fragile designs inappropriate. Such designs are best left to other materials and processes. Aim for large masses and volumes when designing for stone; it is more economical on both stone and effort.

Sculptors to study who have used limestone for their carvings in the past include Eric Gill, Frank Dobson, Henri Gaudier-Brzeska, Constantin Brancusi and Jacob Epstein.

Henry Moore carved the 'Madonna and Child' for St Matthew's Church, Northampton during 1943–44. The sculpture, which is shown here in the process of carving (Plate 6), has a quiet grandeur and monumentality which is due not just to the scale of the work, but to the dignity and solidity of the pose. The massive forms of the body and drapery convey permanence and dependability in the Madonna: she is noble yet gentle.

Carving heads

Heads make good shapes for carving. Some preparatory research with drawing or a clay model should be done to work out the design and proportions before embarking on a head project. Aerated blocks are ideal for carved heads, and plaster can be set in an appropriately shaped box. Stone can be bought in any size, but a stone with strong markings or translucency such as alabaster may not work well for head sculptures if there is too much detail in the design: it simply won't show.

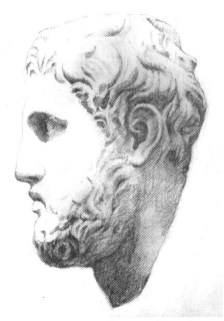

Figure 6.13 From a Greek Head in the British Museum

The Greek sculptor who carved this head (Fig. 6.13) in the British Museum has taken enormous liberties with the human head by exaggerating the relationships between different planes. He has brought the bridge of the nose forward so that the nose and forehead are on the same plane, and pushed the eye back deep into the head. Moreover, the eye itself is on different, receding planes so that the flesh below the eye is greatly pushed back from the lid. Yet despite these exaggerations, the carving is subtle, the effect is heroic, and the style has been copied for centuries since.

Figure 6.14 Head carving: Cycladic and Easter Island sculpture

Many contemporary sculptors have been influenced by prehistoric carved heads such as these Cycladic and Easter Island heads (Fig. 6.13), and Modigliani was among the artists who were inspired by African art; his elongated carved heads have the same nobility and poise that is apparent in a great deal of African carving. The process of carving dictates some simplification of form which is abstract to a degree, and there is plenty of scope for imaginative designs in carved head sculptures.

Further reading

Peter Rockwell: *The Art of Stoneworking: A Reference Guide*, Cambridge University Press, 1993

L. Broderick: *Soapstone Carving*. Technical booklet published by Tiranti

7 | CARVING IN WOOD

Woodcarvers generally need to invest in more equipment than stonecarvers because they need a good workbench for carving. A workmate can be useful, but these tend to be light in weight and will move around, unless anchored with sacks of sand.

A piece of worktop attached to a wall with strong batons and legs will provide a sturdy area for carving, particularly if it is near a window or can have spotlights fixed nearby. It can be tailor-made to the most comfortable height for the carver (Fig. 7.1).

Figure 7.1 A homemade worktop suitable for woodcarving

If you have already invested in a banker for stonecarving, this will provide an excellent bench for woodcarving: vices can be fixed or clamped temporarily and removed for other types of work. The advantage of a banker over a fixed workbench is that it is portable, so that it can be moved to wherever the sculptor prefers to work. A professionally made banker has been designed for the job of carving (Fig. 7.2).

Wood for carving

You will need to take a little trouble to buy wood for carving; a log that has been left outside to shrink and crack will be disappointing to work, and not worth the effort. Buying a piece of well-seasoned timber from a good supplier is essential for the carver, and limewood (basswood in the US) is one of the best woods for carving, particularly for beginners.

Figure 7.2 A banker with wood-carving vice attached

Other woods suitable for carving are fruit woods, such as cherry, apple and pear, also old pitch pine, though the end grain can be rough and difficult to clean up well. There are plenty of magazines for the woodcarver advertising suppliers of wood suitable for carving. Avoid hard woods such as mahogany and oak to begin with.

Tools for woodcarving

A good mallet is essential to a wood-carver. Square-ended carpenters' mallets are not ideal for carving: the weight and balance of these types of mallet are wrong. The best carving mallets are

Figure 7.3 Wood-carving mallet

made of lignum vitae, though some good nylon mallets are now being produced. Like the stone mallets, wood mallets come in a variety of weights from 310g to 815g. It is best to try holding them before purchasing. If that is not possible, a general guide might be that most women prefer to work with 310 to 375g mallets; men prefer 555 to 815g. The size of mallet may depend on the scale of work to be carved, as well as the strength of the carver (Fig. 7.3).

Wood-carving gouges look similar to chisels, but their curved edges or 'sweeps' are designed to scoop wood rather than shave the surface down to a precise line. A catalogue of wood-carving tools can look baffling to a novice, and it is tempting to buy a set of tools as an easy option. This is an expensive way to buy carving tools, as there will inevitably be tools that will not be used.

Start with a few carving tools and build up a set as the level of carving progresses. A good plan would be to start with three or four gouges as illustrated. These are:

- 19mm No. 9
- 12mm No. 9
- 15mm No. 4
- 10.5mm No. 4

All are straight gouges. If you can only afford two gouges to begin with, choose the 12mm No. 9 and the 10.5mm No. 4. These will be fine for a small piece of wood to start the first project (Fig 7.4).

Figure 7.4 Wood-carving gouges

The next important item to buy is a sharpening stone. Carving tools need constant sharpening and honing to keep them working well: blunt tools tear the wood and will cause the tool handles to split because of the extra effort to make them cut. Double-edged sharpening stones that will sharpen the outside edge of the gouge can be bought from most hardware stores. A slipstone will also be needed to remove the burr on the inside. (See separate appendix on sharpening.)

Wood files can be bought from hardware stores, but specialist files called rifflers will need to be bought from a sculptors' or woodworkers' suppliers.

Holding the wood

Wood can be held firm in the hand when doing simple chip carving and whittling, but there are a number of holding devices for wood to free both hands.

A great deal of carving can be done with the aid of a G-cramp, provided the design for the carving is not too round (Fig. 7.5).

Figure 7.5 Holding wood with a G-cramp

If the wood is an awkward shape, a baton of timber can be glued to the woodcarving and clamped to the bench (Fig. 7.6).

Figure 7.6 A baton of timber can be glued to the woodcarving and clamped to the bench

A bench screw will hold the wood firmly to the workbench, but is not suitable for tall designs (Fig. 7.7). Most carvers also prefer to move the wood around at different angles as they work, which will be difficult if working with a bench screw alone.

Figure 7.7 A bench screw

Engineers' vices can be purchased second-hand and are a good investment for any sculpture workshop (Fig. 7.8). However, their metal jaws can bruise the wood, so attach slivers of timber or cork tile to the jaws of the vice to protect the wood.

Figure 7.8 Engineer's vice

If you are carving a flat piece or a relief sculpture, make a frame by screwing four batons to a sturdy board. This can then be clamped to the workbench or table with a G-cramp or holdfast (Fig. 7.9).

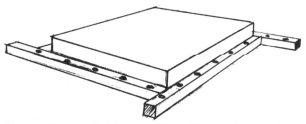

Figure 7.9 Holding a flat piece of wood for carving

An ideal holding device is a carver's vice, which is made out of wood with wide-opening padded jaws. This can be fixed to the workbench with a substantial bench screw (Fig. 7.10).

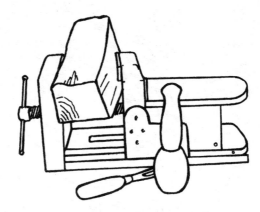

Figure 7.10 Woodcarver's vice

Abstract shape based on candle flame in limewood

You will need:

- a piece of limewood 3″ × 3″ × 11″
- a crayon for marking the wood
- a wood-carving mallet
- wood-carving gouges 12mm No. 9 and 10.5mm No. 4
- a G-cramp or other method of holding the wood
- a wood file
- cabinet makers' paper or fine sandpaper
- beeswax and turpentine for polishing

Draw the shape onto one side of the wood with the crayon. Clamp it firmly to the bench or worktable and cut away the first profile. Large areas can be sawn away: if you have access to a bandsaw, the whole profile can be cut to the drawn line; otherwise, remove corners with a handsaw.

When using the wood-carving gouges, start at the highest point with the No. 9 gouge and carve away diagonally as indicated (Fig. 7.11). This is important, since carving inwards will split the wood. If a hollow is required, carve down from both sides; it is not possible to scoop wood 'upwards'.

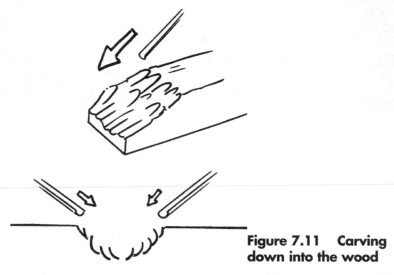

Figure 7.11 Carving down into the wood

The carving may need to be repositioned in order to reach all angles with the gouge. When this profile has been carved, draw and carve the next. There should still be some areas left where the wood can be clamped firmly to the bench (Fig. 7.12).

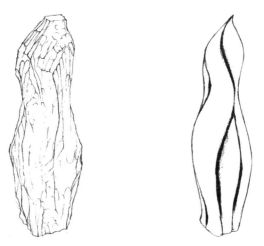

Figure 7.12 'Flame': woodcarving (a) in progress and (b) completed

Use a smaller gouge to refine the shape. If the wood is too awkward to hold in a clamp alone, glue it to a block of timber that can be clamped. Any carving from then on will be done with a lighter touch.

After carving, the wood can be filed. As with stone files, wood files should only be used in a forward movement; rubbing files backwards and forwards on wood soon wears them out. Follow the line of the grain in a downward movement in the same way as when you are carving: you will soon feel if you are going against the grain from the way the wood rips.

Filing can be completed most comfortably on your knee, as can sanding and polishing. Wear an old apron to protect clothes from wood dust and wax.

Finishing a woodcarving

Sanding is best done with the finest garnet or cabinet paper. At least three grades of paper will be needed to sand the wood, working from coarse grades of paper to fine. Finishing and cleaning up a woodcarving can take longer than the carving process itself.

For a perfect finish, briefly pass the sanded woodcarving under a running tap to wet it. This will raise the grain on the wood. When it is dry, give it another rub with the finest paper. This will give the wood a silky, tactile finish.

All woodcarvers have their own favourite polish for wood. My favourite is beeswax and turpentine. These can be melted and mixed together in an old tin over a pan of boiling water. The softened polish can then be applied with a rag or spatula and buffed with a soft cloth.

Beeswax is a hard polish that is easier to apply in the warmth of sunshine, a heater, or even a hairdryer. Although hard work, beeswax makes a better polish than liquid polishes, which are absorbed into the wood grain unevenly.

There are plenty of books on woodcarving with ideas for design; some even have templates for tracing around shapes. The main thing is to keep an open mind about what you want to achieve, and to design shapes that make the most of the material.

Lindsay Anderson uses texture and colour to accentuate the sculptural qualities of her woodcarvings and to add some emotional content to the subject-matter. Gouge marks are left in some areas, and other areas are roughly scarified with sandpaper before being rubbed with acrylic paint (Fig. 7.13).

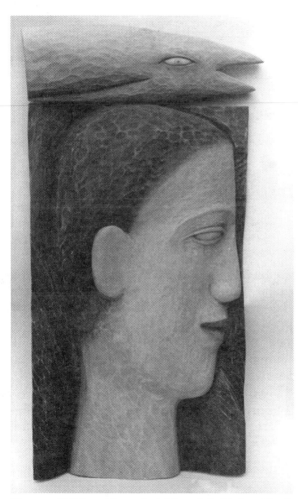

**Figure 7.13 'Angel with a bird', by Lindsay Anderson.
© Lindsay Anderson**

Alexandra Harley's woodcarvings are constructed out of several pieces of pared-down wood that reach out and span the surrounding space. Starting with strong preconceived ideas for the shapes, she allows the sculptures to develop organically as they progress (Fig. 7.14).

The woodcarving on the cover by the author represents a series of tightly packed forms that are about to unfold. The knot in the centre of the wood makes a focal point around which the shapes are folded. The piece would not have succeeded if the knot had been elsewhere.

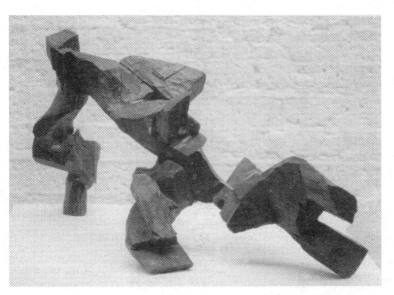

Figure 7.14 'Loppestre', 1992, by Alexandra Harley

Appendix: Sharpening tools

Carving tools have to be sharpened frequently. A blunt tool will wear out the carver and split the tool handle. Moreover, wood carved with blunt tools will tear, rather than cut, or the tools will stick in the wood.

Carving tools need sharpening every fifteen minutes while they are being used; it doesn't take long, and the benefits are immediately apparent. A combination oilstone is the most useful sharpening stone. It is rough on one side for quick sharpening, and smooth on the other for honing or fine sharpening.

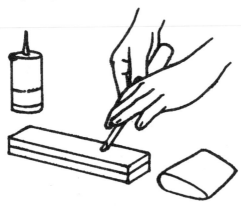

Figure A.1 Sharpening gouges

Sharpening stones need lubricating with oil: bicycle oil is good, but honing oil is better. Hold the tool over the stone at the angle of the bevel (about 30°) and push it along the oilstone in a backwards and forwards movement. Move the tool all over the stone to avoid making a groove, which will make the oilstone unfit for even sharpening. Move a flat tool in a zig-zag fashion; a gouge should be sharpened in a figure-of-eight.

Wood-carving gouges can be sharpened in a backwards and forwards movement, rocking the tool to ensure that the entire edge is honed. Another way is to move the gouge in a sideways action while rocking the tool. Again, a figure-of-eight motion will prevent grooves forming in the sharpening stone. A little pressure can be applied with the left hand (Fig. A.1).

The tools may build up a 'burr' of metal on the topside: this can be removed by stroking the tool top with a slipstone. These are made in different shapes to fit inside gouges (Fig. A.2).

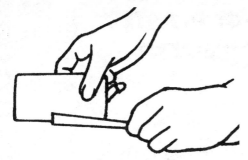

Figure A.2 Sharpening gouges

If a gouge or chisel has been chipped, it may be necessary to grind the tool. An electric or hand grinder is necessary for this and, unless you feel confident with such machines, it may be worth returning the tool to the manufacturer for professional reshaping.

If you have access to a grinding wheel, remember to:

- wear goggles or eye protection and keep the guard down
- cool the tool every 2–3 seconds
- steady the tool on the toolrest

Cooling the tool is essential when using the grinding wheel, or the temper will be ruined. Keep a cup of water beside the grinder for dipping the tool.

Wet grinding wheels are safer for novice sharpeners. The grinder incorporates a bath for soaking the wheel.

Synthetic wheels do not need cooling, and can be fitted to a bench-mounted drill. They are excellent for fine honing, but not coarse enough for initial rough sharpening. Barbers' strops are also good for polishing and honing carving tools.

I use electric grinders for stone tools that require less finesse and a combination oilstone for wood-carving gouges. Every so often, I return the gouges to the manufacturer for a professional sharpening service. It is well worth doing.

8 DIRECT PLASTER AND CEMENT

Plaster and cement can be used in a variety of ways for sculpture. Casting these materials has been covered in Chapter 5, but they are both highly suitable for modelling directly. The advantage of modelling directly in plaster or cement is that the sculpture does not have to be cast for permanence.

Plaster

The disadvantage of working directly in plaster is that the pot life is quite short unless retarders are added. Old-fashioned retarding agents include vinegar, borax, glue size and alcohol; all affect the strength of the plaster and should be used with caution. The retarder recommended in sculptors' shops is trisodium citrate, which is said to extend the pot life of plaster to about one hour.

The working area needs to be covered with builders' plastic sheet to protect the workbench and floor. This has enormous benefit when clearing up while working, as plaster waste can be shaken into a corner and swept away.

You will also need:

■ plenty of mixing bowls – microwave trays are ideal if rubber plaster bowls are not available
■ scrim
■ plaster scrapers or filling knives
■ scissors
■ a surform
■ files and rifflers

For forming the shapes you will need:

■ chicken wire

- armature wire and/or coathangers
- PVA glue

A large bucket of water for rinsing hands and tools is essential.

There are a few types of plaster available for the sculptor that have varying degrees of hardness. Choose the most basic plaster of Paris or dental plaster until you develop skills in using the material. Although some builders' merchants sell plaster of Paris, make sure to buy this, and not wall-coating plaster. It may come under a number of names: fine casting plaster, superfine casting plaster, dental plaster, normal SP plaster, or No. 1 moulding plaster. If in doubt, visit the local art shop, pottery or sculptors' suppliers.

Plaster has a fairly short shelf-life and needs to be stored in a dry place. It is advisable to put the bag of plaster in polythene or a plastic bin to keep out moisture. If kept dry, plaster will keep for around six months. The older the plaster, the shorter the pot life or length of time to work it.

Plaster is dusty: wear a mask, or mix plaster outside or in a well-ventilated area. Mix small quantities when working with plaster, or it will waste. Never rinse hands or plaster bowls in the sink. Always use a bucket of water. Allow solid particles to settle, then pour off the water. The residue can be poured into a rubbish bag with screwed-up newspaper to absorb any other liquid waste.

Any plaster that has gone too hard to work should be left in the bowl to set completely. It can be knocked out into a rubbish bag when set, particularly if the bowl is flexible. Sculpture studio sinks have special traps to deal with this problem (Fig. 8.1), although these too need to be cleared. It is best to acquire good, clean working habits to avoid problems later.

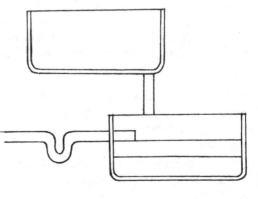

Figure 8.1 Plaster sink trap

Abstract plaster sculpture based on two interlocking rings

Cut two strips of chicken wire with tin snips or pliers, and form into rings (Fig. 8.2a). Tie the rings together with tiewire, or twist the ends of the chicken wire to join them. Cover the chicken wire with one or two layers of thin cotton scrim on both the inside and outside of the shape (Fig. 8.2b). Paint the scrim with PVA glue and water mixed in equal parts (Fig. 8.2c) and allow to dry completely. This will provide a stiff surface for spreading the plaster. Alternatively, bind the chicken wire with plaster bandage, wet, and allow to set. The latter method may be heavy and cause the framework to distort, in which case, support the frame until the plaster sets. Do not be tempted to use too much scrim or bandage: it should be well below the surface of the sculpture, or it will be a nuisance and show. The purpose of the scrim or bandage is to stop the plaster falling through the holes in the wire mesh.

(a) **(b)** **(c)**

Figure 8.2a,b,c Stages in creating abstract plaster sculpture based on two interlocking rings

Once the bandaged layer is set, a small amount of plaster of Paris can be mixed and spread over the framework with hands, plaster tools or a spatula. Allow the plaster to set, and scrape the surface smooth. Carry on spreading fresh plaster and scraping down until a satisfactory edge is achieved.

If some time elapses between working sessions, make sure that the plaster sculpture is thoroughly wet before adding new material. Run it under a tap or immerse it in a bowl of water to saturate the plaster. New plaster will not adhere properly to dry plaster: it will turn crumbly and weak as the moisture is leached from the new mixture. Similarly, patching should be done to wetted plaster and smoothed with wet fingers.

Linear structures can be made by wrapping armature wire with thin cotton scrim, glue and plaster (Fig. 8.3). Look at the 'Knot' sculptures of Wendy Taylor from the 1970s to see some exciting shapes that can be made with wire-framed armatures.

Figure 8.3 Linear structure made by wrapping armature wire with thin cotton scrim, glue and plaster

The sculptor Henry Moore used direct plaster for his sculpture 'Three-Way Piece No. 2 (Archer)' of 1964 (Plate 7): a framework was made with wooden struts and plaster-soaked scrim to establish the form. Plaster was then modelled and filed until precision was achieved in the edges and curves. The plaster was later cast into bronze. Moore made a number of direct plaster sculptures: his versatility with different materials was astonishing. Although he was an accomplished carver in wood and stone, most of the large figure sculptures were made in the direct plaster method.

An armature for a head sculpture can be made simply with chicken wire or wire netting and squeezed into shape with the hands (Fig. 8.4).

Figure 8.4 Armature for head sculpture

It is best to keep the wire under size, particularly at the front of the sculpture, to allow for recessed areas such as the eyes. The wire is covered with scrim and painted with PVA glue to make a firm base for the plaster; alternatively, plaster bandage can be wrapped around the wire and wetted 'in situ' in preparation for modelling (Fig. 8.5).

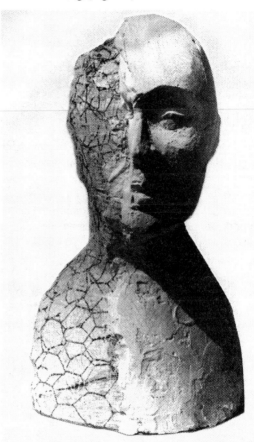

**Figure 8.5
Applying
plaster to the
armature**

The texture and finish of direct plaster is different from the texture of sculpture that has been made in clay and cast in plaster. Fine detail is difficult, so the process lends itself well to simplified form. The sculptor Elisabeth Frink used direct plaster for most of her sculpture. The appeal in the method was the speed with which a piece of sculpture could be

realised. Frink also liked the tough, carved effect that plaster produced, which was ideal for the subjects she chose when depicting the male figure. Through her career, Frink's sculptures evoked many sentiments: heroism, brutality or vulnerability. The 1981 sculpture from the Tate collection: 'In Memorim 1' is wistful, stoic and resigned (Plate 8).

Few sculptors leave plaster as it is. It can be sealed with shellac when dry and painted with a bronze finish. Moulds can be taken from plaster sculptures, but they should be flexible moulds for easy release.

Cement

Another material that is suitable for direct modelling is cement. Cement is ideal for outdoor sculpture: large pieces can be undertaken easily with patience and care. Armatures are made in chicken wire, but they need to be extremely accurate in form: the cement is much harder than plaster and will not rasp or file easily.

The armature is covered with scrim, PVA and a layer of glassfibre. This should dry overnight and harden. Mix some cement and sand to a ratio of 1:1 with water. Dip some thinly shredded glassfibre in the cement mixture and apply to the wire frame, *starting at the base* of the sculpture, to a height of approximately 12″ or 30cm. Cover the cement with polythene to allow slow curing, and leave it to set overnight or longer. Each section can be covered with the cement and glassfibre mix a little at a time, and allowed to set: the reason for building cement sculptures this way is to avoid too much weight on the armature at once, thereby causing it to sag. Cement is a heavier material than plaster, and takes a great deal longer to set.

Once the whole frame has been covered with cement, sand and glassfibre, it will be strong enough to start some serious modelling. Always wet the sculpture before adding new material: the addition of PVA glue (Unibond) to the cement mixture will help with the bonding, though it is not always essential. The cement recommended for this type of sculpture is ciment fondu: it is dark grey in colour and has an attractive finish, which can be burnished with a brass wire brush. A similar cement is Secar, which has all the properties of ciment fondu but is white in colour. Use silver sand with this cement to prevent coloration.

Cement will set down a sink even more than plaster, so avoid rinsing bowls and buckets anywhere near the plumbing. Scrape any residue into

a wastebag, and wipe bowls with newspaper. There should not be as much wastage with ciment fondu as with plaster: it has a long pot life and can be damped to extend working time.

There is no special way to mix cement, unlike plaster, although it is easier to combine cement and sand while dry before adding water. The main things to remember about cement are that it must set slowly, and must not be left mixed in a large mass without sand, or it may combust.

Other materials for direct modelling

Papier mâché can be built on chicken-wire frames. This can be ordinary newspaper stuck with glue, or pulped paper that has been prepared as a modelling medium. Other materials that can be modelled directly are Ferracotta and resin, as well as some imitation stone.

**Figure 9.1
Construction
made from
drinking straws**

**Figure 9.2
Construction
made from
drinking straws**

9 | CONSTRUCTION

Construction is a method of making sculpture from different parts or elements. Russian artists such as Naum Gabo, Vladimir Tatlin and Alexander Rodchenko are generally associated with the beginnings of constructed art, because they were the first to abandon traditional sculpture materials (that is, clay, bronze and stone).

The Constructivists, as these artists were called, chose wood, cellulose, metal rods and other light materials for assembling structures, many of which resembled architectural or scientific models.

As an art form, construction is a good, quick way of making sculpture, some of which can be tackled easily and cheaply with little equipment and materials, most of which can be bought from the local hardware store. It can be a satisfying method, since there is usually no need for further processes other than painting and mounting. Moreover, it can be fun.

Constructions with straws and glue

The two constructions shown in Figs 9.1 and 9.2 were made with drinking straws, thread and glue. A packet of drinking straws can provide enough material for a number of construction projects. Sewing-thread will hold the structure while the glue sets, leaving the hands free to manoeuvre the straws until a satisfactory design is made.

Start by taking 8 or 10 straws. Bind them with thread and move them about until they create a dynamic structure. Squeeze glue liberally into the centre – balsa wood glue or modelmakers' glue is best. Remove any spare thread with scissors.

Another way to build structures is by assembling triangular units and linking them with glue or thread. To make a triangle, thread can be passed through short lengths of straw with a large needle, and knotted (Fig. 9.3).

These triangles can then be assembled with glue (or thread, if patience permits) to make larger structures. The drinking straw construction can be sprayed with paint later.

Figure 9.3 Assembling straws

Other materials that can be used for this type of structure are matches, cocktail sticks, garden canes or small mouldings. If construction is a favourite method of making sculpture, it may be worth investing in a good glue gun for quick assembly.

The main disadvantage of construction is holding the various parts while they glue together. A small amount of clay, plasticine, or even masking tape can hold joints while the glue dries, or until the structure is strong enough to be self-supporting.

Constructions with wood

You will need:

- a good saw
- some sandpaper
- woodglue

You may also need:

- a vice
- a hand drill and set of wood drill bits

Fig. 9.4a: take some small scraps of wood of different thicknesses and widths, or buy two or three lengths of different shaped moulding. Cut one square piece the length of the intended structure, and subdivide each side with a variety of vertical and horizontal superimposed pieces to create a well-balanced and visually exciting structure.

Fig. 9.4b is based on the ideas of the American sculptor David Smith. Smith was a metalworker: his series of 'Cubi' designs of the 1970s were

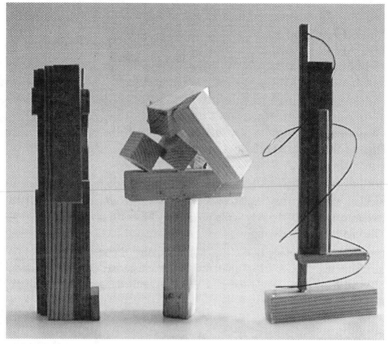

Figure 9.4 Constructions in wood

made of highly finished welded steel. The structures appear to grow like trees made of tantalisingly balanced cubes and rectangular shapes. Since only the corners touch, there is not enough surface for gluing, thus creating a need for an additional method of fixing.

Once the shape of the structure has been decided, each piece will need to be fixed with the help of a jointing aid. If the structure is small, a piece of metal such as coathanger wire is ideal. A small hole the same width as the wire is drilled into the corner of the cube, and the wire inserted. It is difficult drilling into a corner without the drillbit skidding about, but a small notch cut into the area to be drilled will give the drillbit purchase.

Holding small pieces of wood while drilling or fixing presents problems if there is not a vice (or a brave friend) to hold the wood while you drill. Use a piece of clay or plasticine to grip a small piece of wood tightly enough to work on. Larger structures can be fixed with dowel. The

combination of dowel and glue can join quite large structures in wood if the design is well balanced.

Fig. 9.4c. To make this structure stand on such a small area, it will be necessary to drill a hole in the base. The bottom of the main upright can be whittled with a sharp knife to fit the hole. The starkness of the vertical and horizontal planes is broken by a coil of wire winding through the composition and it is fixed by inserting the ends in small, drilled holes. Anything can be added to a structure like this: cut card, thin metal sheet, and springs. Try varying the sizes of the parts of the structure, as well as combining different materials.

Larger shapes should be hollow. They can be made from card, thin MDF or matchboxes. Tumbling shapes can be made effective by inserting boxes within boxes. Provided the whole structure is stuck firmly to a heavy base, designs can be dynamic and full of movement, despite having a fairly static shape as a starting point (Fig. 9.5). A good example of tumbling and spiralling boxes is the new design for the Boilerhouse gallery at the Victoria and Albert Museum in London. Its siting may cause controversy, but the design itself is pure sculpture.

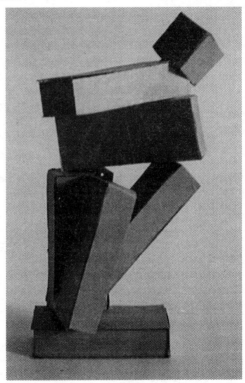

Figure 9.5 Tumbling boxes

The box frame construction (Fig. 9.6) was made from an idea by Cornelia Parker. Small pieces of wood have been threaded on nylon fishing wire

and suspended from the top of the box construction. If the suspended objects are fairly light, they can waft freely to include movement as another element of the piece.

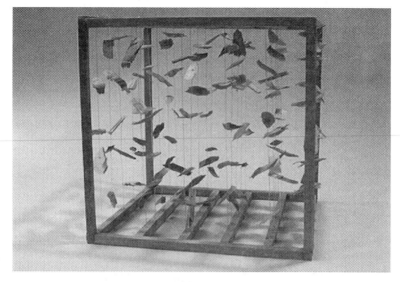

Figure 9.6 Box construction with wood and nylon

All sorts of objects can be suspended in frames, and many artists have chosen this method of presenting their work. Alberto Giacometti was making suspended, framed sculptures as far back as 1930, and the effect of contained, surreal space must have influenced many painters and sculptors since those early works which were among his most imaginative sculptures.

Constructions in metal

Thin metal sheet can be joined with a hand riveter (Fig. 9.7). Food tins can be cut with metal snips, or even strong scissors, to make light metal sculptures without the need for welding. It is best to wear old leather gloves for cutting metal in case hands or fingers are snagged.

The metal has to be drilled first, with a drillbit slightly larger than the rivet. The rivet has to pass all the way through the metal pieces before pressure is applied with the riveter (Fig. 9.8). The rivet will spread out and

Figure 9.7 A rivet gun

Figure 9.8 Riveting

flatten on the reverse side of the work. Any additional flattening can be done with a hammer afterwards, if the rivet joint is still too round.

Try assembling some simple shapes with old food tins (Fig. 9.9) to practise riveting before designing a more ambitious piece.

Figure 9.9 Riveting old food tins to make structures

Polystyrene constructions

Polystyrene can be purchased from builders' merchants in different sizes and widths. It can be glued with polystyrene cement, cut with a sharp knife, filed and sanded (though this makes a terrible mess). Polystyrene is useful for building large, light shapes which can be painted or covered with more durable materials, such as cement or resin. The sculptor Tony Cragg makes constructions with pieces of turned polystyrene. Though he has covered the material lightly, he has made no attempt to disguise the original material underneath.

Some sculptures can be cast directly in the foundry from polystyrene, as it melts when touched by hot metal. This sidesteps the need for lost wax casting.

10 SCULPTURE IN WAX

Wax sculpture should not be considered 'permanent' as such. If a wax sculpture is left in the sun or near a radiator, it will distort. However, there are examples of wax sculptures in the Victoria and Albert Museum in London that have survived hundreds of years intact. If kept in reasonable conditions, wax sculptures will last well.

The wax relief by Giambologna (Plate 9) shows Christ before Caiaphas, and is an example of wax modelling at its finest. The soldiers are so exquisitely modelled that they almost distract the viewer from the central figure of Christ. The bored-looking fellow on the left is keenly observed, and the artist has made full use of perspective with the architectural motifs in the background. Compare this to the section of Trajan's Column (Fig. 1.7, page 9) from a few centuries earlier.

Giacometti used direct plaster for many of his thin figures, which he later cast in bronze, but modelling directly in wax can save the process of casting for semi-permanent sculptures, particularly if rosin has been added to the wax mixture.

Another, modern, sculptor who used wax was the Italian Medardo Rosso. He modelled his sculptures in clay and cast them later in wax. Once the sculpture was released from the mould (which was flexible), Rosso would manipulate the wax to refine or subdue the detail. The result was the combination of the most exquisite modelling and fleeting impressionism.

There are several types of wax available for the sculptor, and the choice for beginners can be difficult. The more expensive kinds of wax are malleable and can be softened in the hand: Scopas modelling wax type B or Victory Brown are popular examples of soft waxes that are ready to use. Red modelling wax is a mixture of paraffin wax and beeswax which has to be melted in a pan first, then poured onto an oiled marble or melamine surface to cool. It takes a few seconds for the wax to become opaque and

cool enough to lift with a scraper and knead into a malleable state. Another type is microcrystalline wax which can be used on its own or mixed with other waxes for modelling. This wax also needs melting.

Care should be taken when melting wax over a gas cooker; it is safer to melt wax in a double saucepan over water to avoid the risk of fire. (Wax melts at between 50° and 75° centigrade.)

Electric cookers are less of a hazard; wax can be melted in a pan directly over the heat without risk of setting it alight, but take care not to overheat it or to splash it on the skin when hot.

To get the hang of working with wax, try different mixtures; alter the ratios of beeswax to paraffin or microcrystalline wax and try hardening the wax with rosin. By adjusting and modifying the waxes, different qualities of flexibility and cohesion can be achieved. Buy small amounts of wax (half a kilo at a time) to begin with until familiarity with the material is achieved. Wax takes a little patience at first but does have some advantages, in that it does not dry out like clay, and can be good for fine detail.

Figure in wax

You will need:

- modelling wax
- a small knife or wax modelling tools
- metal coathangers, copper wire or welding rods
- netting staples and tie wire
- a thick modelling board
- a piece of marble or melamine worktop
- an old saucepan
- a candle
- a scraper
- a rag or piece of kitchen paper towel

Make an armature out of coathanger wire or welding rods by securing the various parts with tie wire. Pin the armature to a thick wooden board with netting pins (Figs 10.1 and 10.2), and bind the armature with tie wire to make a 'key' for gripping the wax.

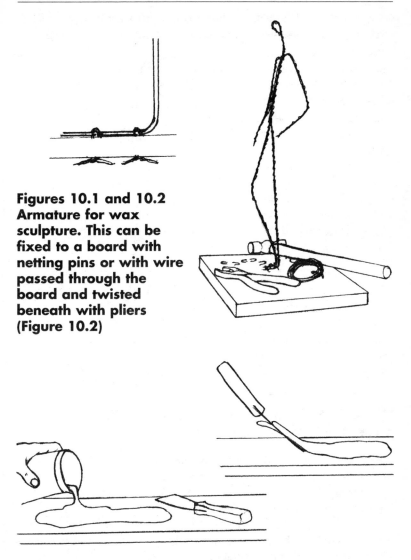

Figures 10.1 and 10.2 Armature for wax sculpture. This can be fixed to a board with netting pins or with wire passed through the board and twisted beneath with pliers (Figure 10.2)

Figure 10.3 Melted wax is poured onto an oiled marble slab or piece of melamine board to cool

Figure 10.4 Wax is scraped off the oiled board as soon as it becomes opaque

Pour, scrape up and knead the melted wax (Figs 10.3 and 10.4), press small pieces onto the armature and squeeze the wax firmly with your fingers.

Allow the wax to set. Build the forms a little at a time with fingers to develop the shape. If the shape has to be reduced, use a hot knife or wax modelling tool to cut through the wax: these are useful tools for cutting and for modelling fine detail. Wax modelling tools can be heated in a candle flame (which can leave a sooty deposit unless the tool is wiped quickly on a rag or kitchen towel before retouching the wax). Some sculptors find the carbon marks add an attractive patina to the piece, but others prefer to keep the work clean.

Figure 10.5 Soft wax is kneaded with the fingers and pressed onto the wire armature

This piece may look in the style of Giacometti with elongated forms and thin limbs, but the pose is far too languid. Giacometti's male figures stride or point purposefully, and his female figures stand passively, as if awaiting orders. When modelling a figure the gesture and pose are as important as the form, so make sure that the armature is right before starting. Once the wax is modelled, the armature wire cannot be moved much without disturbing or cracking the sculpture.

Wax sculptures do not always need armatures. Delicate flower petals and drapery can be made by folding thin sheets of wax. Abstract forms can be built without too much concern for structural stability, since the material is light and wax sculptures can be fixed into a base when finished.

11 | COLOURING AND PATINATION

Most sculptures need some sort of finishing: wood needs sealing, stone sometimes needs oiling and polishing, and anything that has been cast will need some attention.

Sealing plaster

A sculpture that has been cast in plaster can be left in its pure white state, though it is liable to absorb dirt and can look bland. Many sculptors prefer to seal plaster sculptures and paint them with a variety of colours and finishes. PVA glue can be used to seal sculpture, but it must be diluted with water 1:1. The traditional sealer for plaster is shellac.

Shellac comes under various guises. You can make it yourself by soaking shellac flakes in methylated spirit overnight, or buy it ready-made in specialist shops. Shellac is also sold as 'white polish' or 'button polish' in hardware shops.

It is important to dilute the shellac slightly or it may clog the texture of the sculpture. Shellac is diluted with methylated spirit, and you will also need this for cleaning the brushes afterwards. Test the porosity of the plaster on the base of the sculpture and adjust the shellac accordingly. It will dry quite quickly.

Painting plaster to look like bronze

There are several ways of faking bronze sculptures. Whichever way you choose, you will need two different colours. Choose dark shades for a more authentic effect. Both the methods described below require some practice. Test them both on the bottom of the sculpture first, and remember to seal the plaster with two or three layers of diluted shellac before you begin.

Method 1

Paint the whole sculpture with dark (old penny) bronze and allow it to dry. Make a pad with cotton and dip this into a saucer of ordinary bronze colour. Touch the surface of the sculpture with a gentle dabbing action. The top surfaces will be lighter in colour and the recesses should stay dark. The effect should be that of a weathered bronze sculpture.

Method 2

Paint the sculpture with light bronze and allow it to dry. Take some black or dark bronze paint and apply it to the sculpture over a small area. Rub the area with a soft cloth to remove most of the dark paint before it dries fully, to reveal the lighter colour underneath. The dark paint should stay in the recesses, giving the sculpture a worn, patinated appearance. Work over the rest of the sculpture a little at a time.

Other colours and pigments can be mixed with shellac, depending on taste and preference. They can also be used on cement and fired clay. When painting unfired, nylon-reinforced clay, check if there is a particular sealer or varnish to go with the product before painting with any of the above finishes.

Another good finish for sculpture is old-fashioned grate polish (Zebo). This is applied sparingly with an old toothbrush and rubbed to give a hard metallic shine. It may need a light spray with fixative when finished.

These methods of colouring sculpture are highly suitable for disguising cheap materials such as plaster and cement, but there are many sculptors who use colour for the sheer joy of it. The ancient Greeks and Romans painted most of their sculpture and architecture with vivid colours. The white, carved stone that we see now is not what the Greeks and Romans saw.

The French sculptor Nikki de Saint Phalle uses bright colours, patterns, mosaic and glass to make the most exuberant sculptures, and many other artists use colour in highly individual ways. Look at the work of Picasso, Louise Borgeois, Anish Kapoor and Shirazeh Houshiary among many others.

The main thing about painting sculpture is that you still have the form: the shape. If the painting is wrong the sculpture can be repainted at no great loss, provided the first layer is not too thick. Like anything else in sculpture, painting and patination takes practice and patience.

12 ENVIRONMENTAL ART AND INSTALLATION

Both environmental art and installation could be considered fairly recent developments in sculpture. As works of art, they are mainly temporary, ephemeral.

Environmental art

'Environmental art' is an umbrella title for sculptures or installations made with natural materials found at the site of the work. The aims of environmental art are to draw attention to the surrounding landscape or nature at large. (See three sculpture trails in the UK, listed on p.136.)

One of the first and best-known pieces of environmental art is Robert Smithson's 'Spiral Jetty' made in 1970. It is a huge earthwork made from rocks laid in a spiral path into the Great Salt Lake in Utah, USA. Smithson's creations were conceived in terms of reorganising the landscape, preferably where previous environmental damage, such as mining or quarrying, had occurred. The impact is spectacular.

Another artist, Richard Long, makes barely discernible marks in the landscape. Long's principal activity is walking (often in straight lines), and he marks his passage with minimal intrusion on the landscape (a line of stones or other modest marks). His journeys through the landscape are recorded by photography.

Andy Goldsworthy is an artist who works with indigenous materials in the landscape. He uses rocks, leaves, snow and water to create beautiful and transient sculptures. Because of the nature of the materials he uses, his work is fragile, temporary, and also has to be recorded by photography.

When environmental artists hold exhibitions in galleries, it is often by assembling 'natural' materials on the floor space or over walls, but the impact of these gallery shows is never quite the same as viewing in the

landscape. However, themes of spirals and circles can provide would-be environmental artists with opportunities to experiment with 'found' natural objects like sticks or stones. This could be on a small scale as shown or on a large scale in the garden.

Figure 12.1
Circle of twigs

Figure 12.2
Circle of stones

Creating patterns on a floor space (Figs 12.1 and 12.2) is not a new idea, indeed the origins are ancient. Mazes have been made for centuries, and rings of rock or stone have been made for symbolic or religious reasons in many ancient civilisations throughout the world.

Geometric arrangements have been used in formal gardens, herb gardens, turf mazes and pavements. Simple patterns can be raked into sand or shingle. A whole garden can become an 'environmental sculpture'.

Installation

Installation could be described as large-scale assembly. An installation is usually created at the site of temporary display.

A combination of techniques and different media can be used for installations which can fill entire rooms. Alice Aycock has made large constructions of 'psycho-architecture' in wood, Joseph Beuys has covered rooms in felt, and Richard Wilson flooded an entire floor area of a gallery with motor sump oil.

'Site-specific' installations, as they are called, could be viewed in the same way as large-scale environmental art, in that the work makes an immediate impact on the viewer. They both make us re-examine and re-define our surroundings. Whether or not these works of art can be considered as sculpture is up to the reader to decide, but the fact that they engage our senses by sharing the same three-dimensional space is undeniable.

Further reading

Andy Goldsworthy: *Hand to Earth*, Viking, 1990
Andy Goldsworthy: *Stone*, Viking, 1994

13 INFORMATION, INSPIRATION AND IDEAS

Gathering ideas

Henry Moore once said that nine-tenths of his knowledge and understanding of sculpture came from the British Museum. As a student Moore spent a great deal of time wandering through the galleries and learning from Egyptian, Greek, tribal and archaic art. He recorded his observations in numerous drawings and made notes about the form and content of his favourite pieces.

Sketchbooks and notebooks are essential tools for any artist. Small doodles can develop into ideas for sculpture and are a good way of recording thought processes for future reference. A small, hardbacked sketchbook that fits into a pocket can be used whenever an idea springs to mind, or when you see a shape that merits drawing.

In addition to sketchbooks, notebooks and scrapbooks are useful for storing limitless visual information. Postcards from exhibitions, or newspaper articles, can be pasted in notebooks with comments and drawings from your own observations. Such notebooks are highly individual and will reflect your unique personality and taste.

There are many ways to obtain images for sculpture. Most libraries are well resourced with art books, and some museum and college libraries will allow access for research. Most will permit photocopying, provided that you do not infringe copyright laws, and some galleries have recorded catalogues of artworks with accompanying texts on CD-ROM.

The most recent source for visual research is the Internet: many collections of sculptures are entered on websites, and individual sculptors are adding photographs and information about their sculpture on the Internet. A few addresses for collections of sculpture are added at the end of the chapter. There are many, many more.

As well as collecting pictures for research, 3D objects can be gathered for ideas and some have been mentioned in Chapter 3. A walk in the country might provide you with a collection of stones, such as these flints found in Suffolk (Fig. 13.1). They are almost sculptures in themselves and could trigger some ideas for a project.

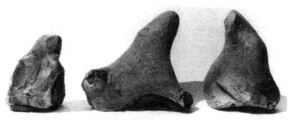

Figure 13.1　Three flintstones

To give an illustration, here are some quick variations of a theme based on the stone on the left (Fig. 13.2).

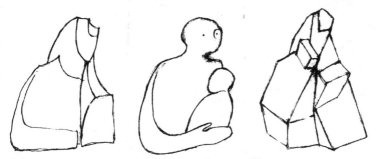

Figure 13.2　Drawings based on a flintstone

Look at drawings by Henry Moore to see how he has improvised the shape of a 'found object' or stone.

The sketches in Fig. 13.3 record the development of an idea for 'Diana of Bennelong' by Australian sculptor Roger McFarlane.

The mythological figure of 'Diana the Huntress' is carved with shapes based on the Opera House at Bennelong Point in Sydney (Fig. 13.4). The shape of the archer's bow is also the shape of the sails that inspired the opera house design, giving the sculpture a uniquely Australian concept.

Figure 13.3 Sketches for 'Diana of Bennelong'.
© **Roger McFarlane**

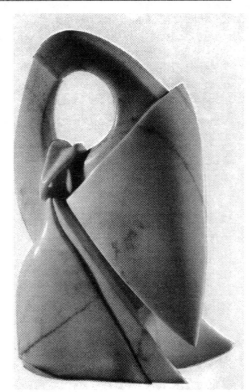

Figure 13.4 'Diana of Bennelong', 1992, by Roger McFarlane.

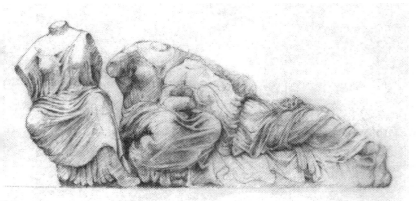

Figure 13.5 Figures from the Parthenon (British Museum)

The three ladies from the Parthenon (Fig. 13.5) have been a source of inspiration for many artists. The massive quality of the sculptures in areas like the knees provides a framework for the more delicate folds of the drapery to stretch and twist. Henry Moore must have had these in mind when making his many seated or 'Mother and Child' sculptures.

Keeping an open and receptive mind is important if sculpture is to develop. Draw, read, and, above all, enjoy making sculpture.

Sculpture parks in the UK

Goodwood Sculpture Garden, Hat Hill Copse, Goodwood, West Sussex PO19 0QP Tel 01243 538449

Barbara Hepworth Museum and Sculpture Garden, Trewein Studio, Barnoon Hill, St Ives, Cornwall Tel 01736 786226

Henry Moore Foundation, Dane Tree House, Perry Green, Much Hadham, Herts SG10 6EE Tel 01279 843333 (by appointment)

New Art Centre Sculpture Garden, Roche Court, East Winterslow, Salisbury, Wiltshire SP5 1BG Tel 01908 862244 (by appointment)

Hanna Peschar Sculpture Garden, Standon Lane, Ockley, Surrey RH5 5QR Tel 01306 79677/269 (check for times)

Yorkshire Sculpture Park, Bretton Hall, West Bretton, Wakefield, West Yorkshire WF4 4LG Tel 01924 830302

Also sculpture trails at:

The Chiltern Sculpture Trail (Buckinghamshire); Tel 01865 483477
Forest of Dean Sculpture Park (Gloucestershire); Tel 01594 833057
Grizedale Forest (Cumbria); Tel 01229 860291

Sculpture parks in Australia are listed in:

Contemporary Sculpture in Australian Gardens by Ken Scarlett, published by Gordon & Breach Arts International, distributed by Craftsman House, 1993
Includes works from the National Gallery of Australia in Canberra, McQuarrie University, Gosford Sculpture Park in NSW and the Museum of Modern Art, Victoria.

Some sculpture websites

http://www.thais.it/scultura.html	1,200 Italian sculptures
http://www.sculpture.org/documents/main.html	International Sculpture Centre
http://www.mq.edu.au/pub rel/scu/.htm	McQuarrie University Sculpture Park, Sydney
http://sheldon.unl.edu/test/pages.biglist/.html	Sheldon University Sculpture Garden, Nebraska
http://www.henry-moore-fdn.co.uk/hmf/image/grounds	Henry Moore Foundation
http://www.tate.org.uk/menui.ht	Tate Gallery, London
http://www.sculpture.org.uk/contents.html	Sculpture parks and sculptors

GLOSSARY

aggregate an inert material mixed with cement to make concrete, e.g. sand or gravel

air vent (or duct) passage allowing air to escape from a mould

armature an internal framework for sculpture, particularly necessary with soft materials such as clay and wet plaster

assemblage sculpture constructed from a number of pre-formed or ready-made materials or 'found objects'

banker heavy-duty wooden bench for carving

baroque term applied to art of the 17th century

bloom residual material left from a plaster mould on a cement cast

bust peg armature specifically made for head sculpture

butterfly internal support for clay inside an armature

callipers instrument for measuring sculpture

carving art of cutting or subtracting material to shape a sculpture

cast a sculpture taken from a mould

casting process of mouldmaking and reproducing sculpture

catalyst a chemical substance which, when added to another material, will cause a reaction such as setting or hardening

cement binding ingredient in concrete

chipping-out removal of a plaster wastemould from a cast

chisel cutting tool for carving or shaping wood or stone

ciment fondu fine, dark grey cement highly suitable for sculpture

claw tool tooth-edged chisel used in stonecarving

concrete mixture of cement and sand or other aggregate with water

construction method of making sculpture by joining pre-formed materials

constructivism twentieth-century art movement originating in Russia, pioneering the use of new materials and technology

coping saw fine-bladed saw useful for cutting curves

Cubism early twentieth-century art movement in which subject-matter was defined in geometric planes

curing setting or hardening of materials like plaster or cement

direct carving a method of working straight into the stone without 'scaling up' from a small model or maquette. The process allows sculptors to develop or improvise their ideas as they carve.

dowel lengths of round-section wood used to peg joints in wood

duct channel for pouring casting material

dummy mallet metal, round-headed, stone-carving mallet

epoxy resin plastic casting material; also strong glue

file metal tool with teeth or other abrasions for smoothing sculpture

filler paste for repairing cracks or indentations

firing baking clay in a kiln to a temperature of at least 1,000°C

futurism twentieth-century art movement originating in Italy, concerned with the expression of movement in sculpture and painting

G-cramp or clamp simple device for holding wood

glassfibre strengthening material for ciment fondu or resin

gothic art and architecture of the Middle Ages, originating in France

gouge curved carving tool

hacksaw saw with replaceable blades for cutting metal

hollow casting method of filling a mould by laminating or layering to avoid too much weight in the cast. Some materials, such as ciment fondu, resin and bronze, do not tolerate solid casting.

key locking device for mould reassembly

laminate application of materials in layers, usually with a brush, for hollow casting

mallet tool for hitting chisels or gouges when carving

maquette small model or 3D sketch for larger sculpture

modelling making forms with soft materials such as clay, wax or wet plaster

mouldmaking process of making a mould

mould a negative form, from which a sculpture can be made in another material

Neo-classical eighteenth- or early nineteenth-century art using classical sculpture and themes

oilstone stone for sharpening chisels and gouges

patina coloured, polished, or worn finish to the surface of a sculpture. This can be achieved naturally in the open air, or artificially with paints or acids.

piecemould a mould made in more than one section

plaster of Paris gypsum cement used for sculpture and mouldmaking

plaster trap sink trap for sculpture studios

plasticity term used by sculptors to describe materials that are easy to model, such as clay

point pointed stone-carving tool. A similar tool, though thicker, is a punch. Both are used to roughly shape stone.

pot life length of time a material can be used before it sets or hardens

release agent solution applied to a mould to prevent it adhering to the cast

relief sculpture that projects from a flat background

riffler small file in a variety of shapes for reaching difficult corners in wood or stone

riveting joining pieces of metal with rivets or flat metal bolts

scaling-up method of copying a small model on a larger scale

scrim loose-weave jute bandage used for reinforcing plaster

sculpture in the round sculpture that is free-standing and has been considered from all sides

shelf-life the length of time material can be stored before deteriorating

shellac traditional varnish and sealer

shim fine brass sheet, used for walling-in piecemoulds

silicone rubber cold-cure mouldmaking material

slip clay mixed with water to a creamy consistency

slipstone small, shaped sharpening stone for removing the burr on wood-carving gouges

terracotta 'baked earth' is the literal translation, but it also refers to the red/brown clay that is highly suitable for firing.

Vorticism Britain's answer to Cubism: a short-lived movement with many famous members such as Epstein and Gaudier-Brzeska

wastemould a plaster mould which is destroyed when released or chipped from the cast

SELECT BIBLIOGRAPHY

E.H. Gombridge, *The Story of Art*, Phaidon, 1957

Germaine Bazin, *A History of World Sculpture*, Studio Vista, 1970

Arthur Williams, *Sculpture: technique, form, content*, Davis Publications Inc., 1995

Barry Midgley (ed.), *Complete Guide to Sculpture, Modelling and Ceramics*, Phaidon, 1982

John Plowman, *The Encyclopedia of Sculpting Techniques*, Hodder Headline, 1995

Bruno Lucchesi, *Modelling the Figure in Clay*, Watson-Guptill, 1980

Peter Rockwell, *The Art of Stoneworking: a reference guide*, Cambridge University Press, 1993

Other technical leaflets published by Tiranti are mentioned in the text.

USEFUL ADDRESSES

The Royal Society of British Sculptors
108 Old Brompton Road, London SW7 3RA
Tel 0171 373 5554 Fax 0171 370 3721
Publishes journals on subscription. Encourages 'Friends'.

The National Sculpture Society
1177 Avenue of The Americas, New York, NY 10036
Tel 212 764 5645
Publishes quarterly journals with useful addresses of sculptors' suppliers,
foundries and professional mouldmakers.

International Sculpture Centre
PO Box 19709, Washington DC 20036
Tel 202 965 6066
Publishes journals with articles on technique and recent developments in
sculpture.

The Sculpture Society of NSW
311 Weemala Road
Terrey Hills, 2084
Sydney, Australia.
Tel 02 94863438 Fax 2294501410
Holds group exhibitions and publishes newsletters.

Association of Sculptors of Victoria
788 Princes Highway
Springvale, 3171
Victoria, Australia
Group exhibitions and meetings.

Suppliers

Sculpture tools and stone suppliers: UK

Tiranti (for all sculptors' tools, materials and equipment)
70 High Street, Theale, Reading, Berkshire RG7 5AR
Tel 0118 930 2775 Fax 0118 932 3487

London shop:
27 Warren Street, London W1P 5DG
Tel 0171 636 8565 Fax 0171 636 8565

Nigel Owen Stone (alabaster, limestone, soapstone)
High Street, Yelvertoft, Northamptonshire NN6 7LQ
Tel 01788 822281

Ashley Iles (for woodcarving tools – ready honed)
East Kirkby, Spilsby, Lincolnshire PE23 4DD
Tel 01790 763372 Fax 01790 763610

W.P. Notcutt Ltd (moulding materials)
25 Church Road, Teddington, Middlesex TW11 8PF
Tel 0181 977 2252 Fax 0181 977 6423

Tool and stone suppliers: US

Peters' Sculpture Supply (for stone)
415 East 12th St., New York, NY 10009
Tel 212 777 1079

Sculpture House Inc (for all sculptors' tools)
30 East 30th St., New York, NY 10016
Tel 212 679 7474

Sculpture Supply (for tools and stone)
222 East 6th St., New York, NY 10003
Tel 212 673 3500

Many more US suppliers are listed in 'The Sculpture Review' published
by the National Sculpture Society, 1177 Avenue of The Americas, New
York, NY 10036
Tel 212 764 5645

Southwest Stone (small pieces of alabaster)
PO Box 1341, Cedar City, UT 84720
Tel 801 586 4892

Tool and stone suppliers: Australia

CDK Stone (for tools)
21/260 Wickham Road, Moorabin, Victoria 3189
Tel 03 9553305

also at: Unit 1/42-43 Bourke Road, Alexandria, NSW 2015
Tel 02 96902255

S & S Wholesalers (for limestone, soapstone)
10 Pioneer Ave., Thornleigh, NSW 2120
Tel 02 98751155

Tracks Sculpture (for soapstone)
60 Fern St., Islington, NSW 2296
Tel 02 49622608

Emco Machine Co Ltd (for tools – supplies goods from Tiranti)
Unit 2, 247 Rawson St., Aubon, NSW 2144
Tel 02 26484377

Western Australia Limestone
41 Spearwood Avenue, Bibra Lake, WA 6163

Carbatec (for wood-carving tools and rifflers)
44 Cambridge St., Coorparoo, Brisbane, Queensland 4151
Tel 07 33972577 Fax 07 33972785

also at: Unit C1, 200 Coward St., Mascot, NSW 2020
Tel 02 93172700 Fax 02 93174838

also at: 370 Swan St., Richmond, Victoria 3121
Tel 03 94278444 Fax 03 94278448

Walker Ceramics (for clay and clay tools)
98 Stanley St., Killarney Heights, NSW 2087
Tel 02 94515855

For a list of suppliers of tools and materials in NSW, contact:

Roger McFarlane at Tracks Sculpture Shed, 60 Fern Street, Islington, NSW
Please send a stamped, addressed envelope.

Tracks Sculpture Shed also produces a guide to carving Australian soapstone
(different from American and English soapstone). Send $5 plus SAE.

For a list of suppliers of tools and materials in Victoria, contact:

Elaine S. Pulham
29 Monash Avenue
Olinda, Victoria 3788

Please send a stamped, addressed envelope.

INDEX

TEACH YOURSELF

POTTERY

John Gale

Teach Yourself Pottery provides a comprehensive introduction for the beginner, and a useful reference for the more experienced potter.

Step-by-step instructions equip the reader with the knowledge and skills necessary to progress from simple to advanced pottery techniques. The book is illustrated throughout and provides the student with the know-how and enthusiasm to fully enjoy this creative pursuit.

The book covers

- the origins and preparation of clay
- the working of clay
- methods of decoration
- how to pack and fire a kiln
- glazing
- necessary materials and equipment.

John Gale is a practising artist and craftsman and works in many disciplines including ceramics, painting and writing.

Other related titles

DRAWING

Robin Capon

Drawing is fun, and through its wide range of inexpensive and exciting techniques offers us all a rewarding means of self-expression. *Teach Yourself Drawing* is an easy-to-follow, well-structured and comprehensive drawing course for the beginner, as well as a source of reference for those with more experience.

- ■ Learn to select good ideas
- ■ Develop an eye for a good composition
- ■ Cultivate your individual strengths and interests
- ■ Plan your work through different stages

Colour plates highlight various styles of drawing and sketching, using pastels, inks, templates, charcoal, and line and wash.

Each section is illustrated throughout and contains carefully planned projects to support the text and encourage practical skills.

Other related titles

WATERCOLOUR PAINTING

Robin Capon

Watercolour is a popular and versatile painting medium and *Teach Yourself Watercolour Painting* provides an easy-to-follow, carefully planned, and comprehensive course for beginners as well as a handy source of reference for those with more experience:

It includes:

- A clear introduction to materials and techniques
- Easy-to-follow, step-by-step, demonstrations
- Colour illustrations to show different ideas and techniques
- Encouragement to develop your own individual style and approach

Robin Capon is a successful artist and freelance writer.